To our very good
and beloved Mr Paige
P/o come
visit this
summer.
The Wards
+ Nick & Jon

Hugh Casson's
OXFORD

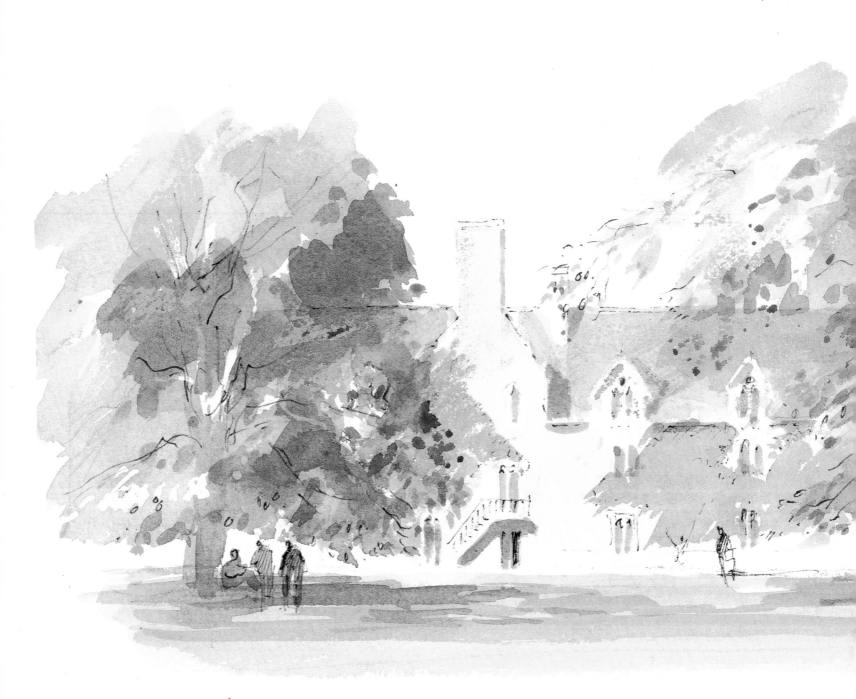

Worcester College —
from the gardens

Hugh Casson's
OXFORD

Φ

I have been lucky enough to receive much help, advice and
hospitality from the members, officers and staff of all the
colleges described in this book. I hope any inaccuracies
will be forgiven, any misjudgements excused and any
discoveries enjoyed.

Phaidon Press Limited
Regent's Wharf
All Saints Street
London N1 9PA

Published in association with the K.S. Giniger Company,
Inc., 250 West 57th Street, New York, NY 10107, USA

First published 1988
First paperback edition 1998
© 1988 Phaidon Press Limited
Text and illustrations © 1988 Hugh Casson

A CIP catalogue record for this book is available from the
British Library

ISBN 0 7148 3810 1

Printed in Hong Kong
Frontispiece: Worcester College

CONTENTS

For David and Anne Piper

INTRODUCTION

Oxford rivals Venice as the most described city in the world. It lies almost buried beneath centuries of words and pictures, most of them celebrating with enthusiasm its wisdom and its beauty.

But it has to be said also that some people dislike Oxford – or more accurately perhaps dislike the *idea* of Oxford. Like Charles I they smell smugness and detect privilege. They find some of its attitudes – the belief, for instance, that those who write and think are in every way superior to those who make and do – not only out of date but as harmful to society as the narrow Faculty/School tradition which emphasizes the divisions of learning. (As we are told, Gibbon never read History because there was no such school.) They find its habit of nailing its colours to the fence pusillanimous and they wonder – with a touch of envy perhaps – whether Truth is best and most rigorously pursued in such soft surroundings. Such criticisms are not new to Oxford, and Oxford can claim in reply that most of them have by now been mitigated or met, and that at least its famous, irregular beauty, though occasionally disfigured by misjudgement, is still there to be discovered and explored.

For, despite all the criticism and description, Oxford – or rather the buildings in which the University lives and works – is still a city of secret places, almost Oriental in their reticent complexity. High walls penetrated usually by small doorways and gates conceal square courtyards and gardens opening one out of the other like a succession of stone-walled roofless rooms in which a chapel or a Hall, a library or a tower is placed as proudly and unexpectedly as some great piece of furniture.

The history of these tiny palaces and their domestic outbuildings grouped round

the places of assembly or ceremony is as fascinating as it is long. The University, though not as old as the city, began as a poor and pious place, its 'colleges' hardly more than student lodging-houses sometimes with an elected head to supervise the earnest fifteen year olds. Who was first with what? The arguments still continue. Balliol claims to be the first to boast a corporate life under one roof; Merton, the first to call itself an endowed college; Oriel the first to boast a library. Over the years more colleges were founded. Bequests and benefactors were increasingly attracted. Fine buildings and spacious gardens were built and laid out, silver purchased (or given) and cellars laid down. But wealth brought problems. Oxford began for a time to slip into a gouty slumber, from which after a stressful nineteenth century it emerged rather tousled to face the realities of the present day. That it does this with modest confidence is due to two factors – the tides of naturally irreverent young people who annually revive its spirits and the persistent, steady beauty of the University's architecture.

Here is a personal choice of some of it, restricted inevitably by wayward preferences and looked at, not through a viewfinder, but eye to eye. It is not a guide-book (there are plenty of those). It is not a history (Oxford is stuffed with historians). Not all the colleges are included. There is nothing about stained glass or vestments, and modern architecture – perhaps because I find it a bit dull to draw – gets a poor look in. The descriptions are brief, the drawings informal, but I have enjoyed doing both and I hope that the results will encourage others to go and look again for themselves and perhaps find new pleasures in so doing.

ALL SOULS COLLEGE

All Souls is a joker in the Oxford college pack – it has no undergraduates and some of its Fellows are weekenders only – but it is a highly distinguished one, and due to the energy and skill of two architects, one amateur, one professional, its buildings are all interesting and, in places, stunning.

The college was founded in 1437 (partly as a memorial to Henry V), and its front quad remains much as it was, despite some nineteenth-century restoration. The chapel forms its north side – the familiar T-shaped plan, a fine painted screen by Thornhill concealing the chapel itself, mixed-quality glass, a reredos like lace embroidery filling the east end and carrying a load of absurd Victorian statues in niches (one of which is an archer, alleged to be a memorial to the fallen men of Agincourt). The antechapel, lofty and elegant, contains fine monuments including a pile of marble books beneath a carved gown hung up for ever in memory of one Stephen Niblett, and fragments of grisaille-painted boards that once covered the reredos.

In 1708 Dr Clarke, the compulsive amateur architect of parts of Worcester College, persuaded the Fellows (at that time it seems an idle and debauched lot) to extend the college northwards. Nicholas Hawksmoor was called in, his first admirable recommendation being 'to retain any building that was durable in respect for antiquity . . . and not to replace it with perishable trash'. His second proposal was to build the new North Quad in the Gothic style. Happily, his advice was accepted – were they all too lazy to argue? – and the result was and is a triumph.

Hawksmoor was at that time one of the three architects to the Board of Works. The other two were Christopher Wren and John Vanbrugh. What a trio! Among his

entrance to
The Codrington Library

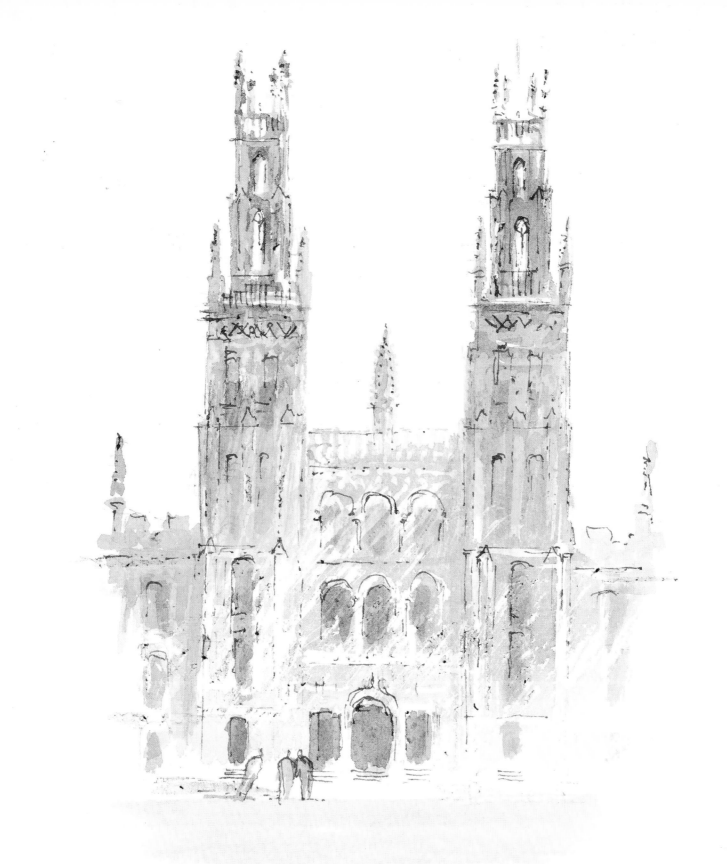

own jobs Hawksmoor worked on Blenheim Palace, Castle Howard, Greenwich Hospital, a score of City churches and the West Front of Westminster Abbey. The executed works he designed include Brasenose College, the Radcliffe Camera and a plan for Cambridge. He was a patient, thorough, unthrusting professional, less celebrated than he should be.

His treatment of the North Quad is masterly. To the west, a low cloister enriched by a central porch carrying the mallard emblem (the origin of one of Oxford's silliest traditions) rises above magnificent iron gates, and permits All Souls to appropriate as its own the Radcliffe dome and the spire of St Mary's. To the east are the famous twin towers, sharp-edged and beautifully cut above the Common Room and, to the north, the centrepiece: the Codrington Library, Gothic without and classical within, with (as its own centrepiece) the giant, richly-coloured sundial attributed to Christopher Wren, at that time the College Bursar.

As elsewhere in All Souls the set pieces are approached sideways or through modest corner doors and cut-throughs. To reach the library from the street you enter a side door no bigger than your own front door, pass through a small square study painted grey and dark grey–green, past caged bookcases, a huge bust of the founder, Archbishop Chichele, a glimpse through the sash-windows of the quad, and then into the library itself, long, lofty and silent, filled with a cool, clear, watery light and, thank heaven, no stained glass. Individual reading-desks stand sentinel by the walls. The floor is patterned black and white. The two-storey bookcases are grey–green, the books leather brown, the lettering gold or black. Urns, busts, balusters and books are ranged in attendance on two huge statues, one of Lord Blackstone in a marble wig, the other of the library benefactor, Sir Christopher Codrington, in a marble toga. (He gave the college £6,000 but it was to cost, as all benefactors come to learn, double that.)

Two hundred years ago, according to a contemporary print, this great silent room was used for promenading ladies and their friends, chattering, one assumes, happily to each other. Today, not even the 'silken thunder' of rich gowns in movement disturbs the dust-motes, and the readers seem frozen at their desks, afraid to disturb the silence by the whisper of a turning page.

It is wise to keep the library to the last, for the Hall, though agreeable enough in its decent livery of stone and wood panelling, with its high windows, gallery and grey marble chimney-piece, Victorian chairs and a portrait of Wren on the north wall fails to twist the heart. But the tiny oval buttery with its curving, vaulted roof set out in subtly diminishing coffers is a perfect coda to All Souls. To sit on a bench trying to fathom the geometry of that magical ceiling is an experience hard to beat.

The twin Towers
of the North Quad
by Nicholas Hawksmoor

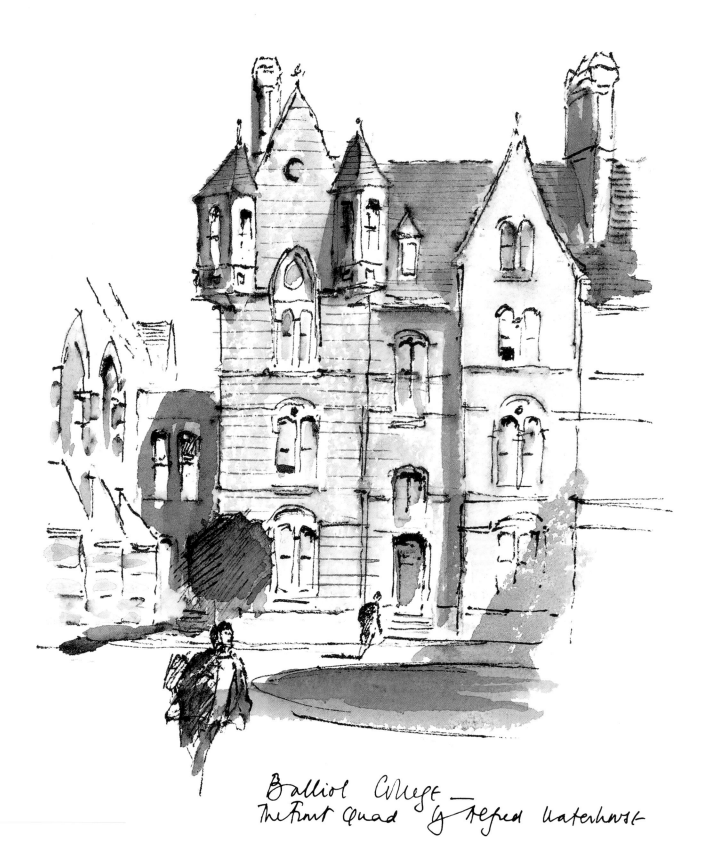

Balliol College —
The First Quad by Alfred Waterhouse

BALLIOL COLLEGE

Balliol, a thirteenth-century Cinderella that became a nineteenth-century princess, is the second oldest college in Oxford, but doesn't look it – at least not from the outside. This is all the sadder as Balliol is one of those rare institutions that generously acknowledge their architects by naming their buildings after them. Ungratefully, the architects, among them Salvin, Basevi and Waterhouse, have not responded with their best, and the structures that straggle like a shelf of second-hand books round the corner of St Giles and Broad Street are for the most part awkward or dull or both. The leader of the pack is the entrance block, the first Oxford commission of the Quaker-born Alfred Waterhouse, who was to become England's busiest and richest nineteenth-century architect; deservedly so. He was practical and reliable. He listened to his clients and read the programmes. He possessed great personal charm (his smile was said to be worth £10,000 a year), and although towards the end of his life he became unfashionable, his most famous and prickliest buildings – Manchester Town Hall, University College Hospital and the Natural History Museum – are now back in favour. ('Only survive', said John Betjeman, 'and you will live to witness your reputation recover.') Sadly, Waterhouse did not; and Balliol's main gate still has few friends. Its most interesting feature is not the vigorous modelling nor the silhouetted turrets, but a simple tablet let into the 'brain-grey' wall by the front door to the Master's Lodge. This records the horrible event of 1536, when a few yards away, on a spot marked today by an iron cross in the roadway, Latimer, Ridley and Cranmer were burned alive for heresy. Latimer's end was mercifully quick, Ridley's a slow agony, Cranmer's a nightmare. Recantations, public humiliation in the streets – but redeemed at the last by great

13

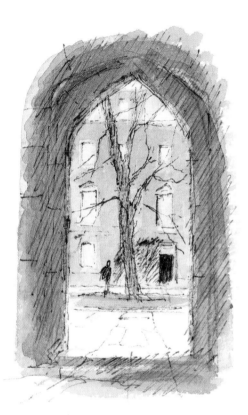

The Archway to Garden Quad

nobility, when with tears streaming down his face he withdrew his recantation and swore that the hand that signed it would go first into the flames . . . and so it did. He kept his promise and his faith, and Balliol, still poor and undistinguished, watched it all so to speak from the cheaper seats.

The first quad through the gateway is tiny and darkly overshadowed by Waterhouse's fantasies but enlivened a bit by Butterfield's striped and stripped chapel, the third on the site. The college never took to this and, indeed, between the wars seriously considered replacing it. Through an archway to the left – the old wooden gate here witnessed the martyrs' burning – are the rest of the buildings, looking like a group of aunts at a picnic and enclosing an enormous quad, irregularly shaped and heavily tree'd, commanded at the north end by Waterhouse's great Hall. This is entered up a thrillingly dramatic external staircase – perhaps the best thing in the college. Left and right of this are placed the post-war, toughly modelled buildings by Geoffrey Beard, which manage to hold their own satisfactorily and pull off some awkward junctions with skill and confidence. To the east, alongside the party wall with Trinity, once lay the twenty-four WCs presented by Lady Elizabeth Perriam, from the roof of which, in 1919, the undergraduates heaved a German mine-mortar, an unwelcome gift from the Government, into the grounds of Trinity next door.

The transformation from an uninfluential theological seminary, Scottish and frugal, to Oxford's intellectual summit was due in part to a Dr Jenkins but principally to Benjamin Jowett (Master 1870–93), the classical scholar, dynamic teacher and reforming educationalist, who believed firmly in the upper classes but also in the need to educate them for a life of action. (In the event, Balliol produced only one viceroy and only one prime minister, but many writers and poets from Matthew Arnold and Swinburne to Aldous Huxley and Graham Greene.)

Jowett knew everybody. To him, the corridors of power were as familiar as the pathways of Garden Quad, and were treated as proprietorially. He was, it seems, snobbish and snubbish. He seemed indifferent to the visual arts but enjoyed music, presenting

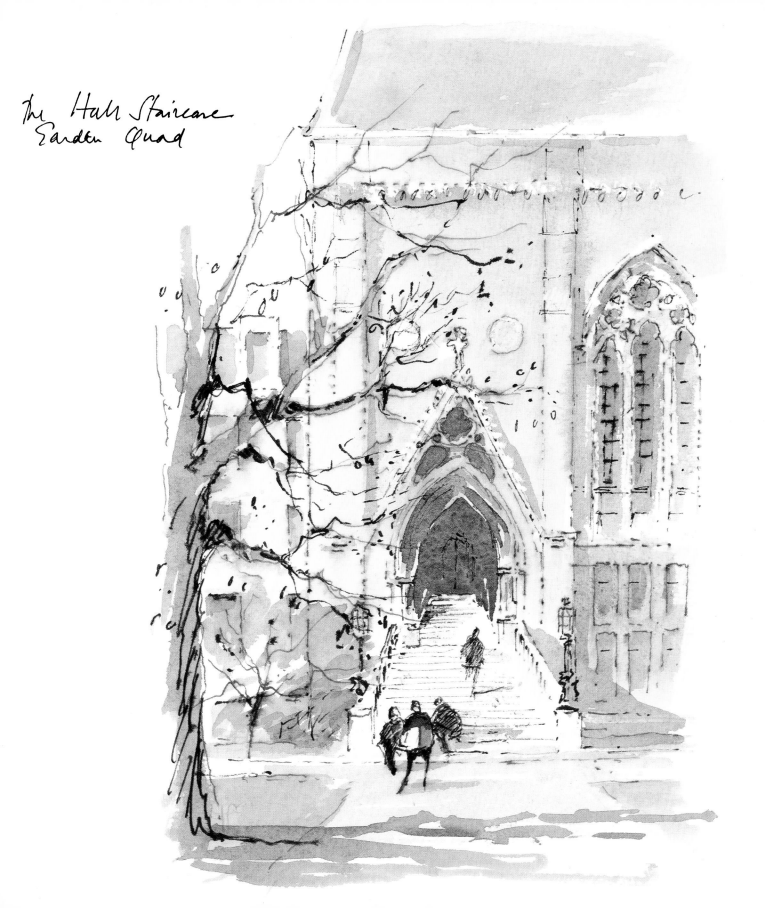

The Hall Staircase
Garden Quad

Chapel Door Detail — by Butterfield

the college with an organ. To look at he was tiny and round-faced, though he was far from boyish in his comments. ('You must believe in God,' he told Margot Asquith, 'despite what the clergy tell you'.) He was, in fact, the epitome of the more progressive nineteenth-century Oxford and no ruder than most. Jowett was the first, perhaps, of those mythical characters, like Urquhart, Bowra and A. L. Smith, who seemed to have captured the affection of their pupils but whose attractions seem impossible to explain to others.

However, he was no misogynist and for thirty years he corresponded with Florence Nightingale ('very difficult she was' he said). He was businesslike and decisive, got the Hall built and extended the library (you can see his effigy on the north wall of the chapel). But even Jowett and Balliol between them couldn't make the college and its additions any nicer to look at. The front quadrangle contains only fragments of its fourteenth-century origins. The Butterfield chapel has been tamely restored inside. The main library was once the Hall (the pretty bookcases are by Wyatt). The varied buildings that line Garden Quad replace a casual collection of outhouses, cottages, stables and a pub. The Waterhouse Hall is gloomy. All true enough. Balliol is undoubtedly a hotchpotch but perhaps it could claim that its endless alterations, patching and rebuilding are solid evidence that it has always moved with or ahead of the times. (It was the first college to employ a woman tutor and to organize adult education summer schools.)

Its reputation for intellectual superiority lingers on. 'God be with you Balliol men', wrote Hilaire Belloc – and God seems usually to have obliged.

BRASENOSE COLLEGE

The Brazen Nose
Door Knocker

Brasenose, as you would expect, seems to derive its name from a bronze door-knocker in the shape of a nose which hung on its Hall door and which, under church law, offered sanctuary to anyone lucky enough to reach and grasp it. The foundation stone was laid in 1509 and within a hundred years the college had attracted nearly a hundred undergraduates.

It enjoyed the usual eventful life of the University, plague and Civil War, Cromwellian purges, and chicanery – the college hanged the college butler for stealing wine – resisting reform and, after years of academic distinction, acquiring a reputation for physical prowess. How Walter Pater, England's first professional aesthete (commemorated by a memorial where he stands confidently in charge of Michelangelo, Leonardo da Vinci, Plato and Dante), endured this celebrated philistinism is hard to imagine.

The buildings are a rum lot, but full of variety and interest. The entrance, the usual sixteenth-century gatehouse formula, faces the Radcliffe Camera and leads into the Old Quadrangle, largely Tudor with some entertaining seventeenth-century dormers. The modestly sized Hall, panelled and plaster-vaulted, has been altered inside. Behind it lies a tiny little courtyard ambitiously entitled 'The Deer Park', dominated by the unexpectedly grand chapel (1795), a fascinating mix of the Gothic and classical. A row of charming oval windows encircling two sides of the quad conceals the actual entrance via the lofty antechapel, and a magnificent fan-vaulted plaster ceiling rides triumphantly overhead.

There's more to come. Beyond again stretches a nineteenth-century New Quad (two centuries ago Sir John Soane had been consulted about this), confidently designed in

Entrance to the Chapel
from Chapel Quad.

his usual free-range style by Sir Thomas Jackson, and very nice too. Behind it Powell and Moya have inserted a discreet and elegant little group of buildings in stone and lead.

The College finishes in a grand but dullish frontage to the High, also by Jackson, this time in a rather more conventional mood. Perhaps after dealing with problems at All Souls, Balliol, Corpus, Hertford, Merton, Trinity, Oriel and Wadham he was momentarily (and understandably) at a loss, and turned, as the English often do when in doubt, to memory rather than to reason and imagination.

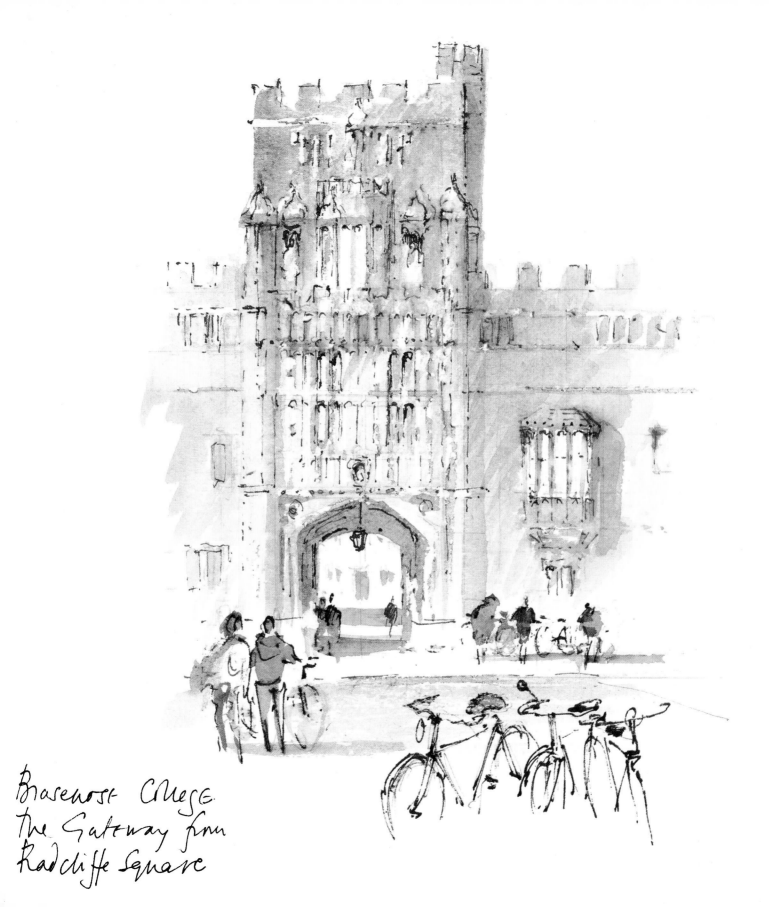

Brasenose College.
The Gateway from
Radcliffe Square

Christchurch . the North Range of Tom Quad

CHRIST CHURCH

Christ Church has had all the advantages plus the adjectives to go with them. It is well connected, rich, handsome, confident and grand – and proud of it. It was founded first by a cardinal, then by a king. Its patron is the reigning sovereign. It specializes in Etonians and can boast eighteen prime ministers and eleven viceroys among its graduates. Its tower was designed by England's greatest architect, Sir Christopher Wren (he insisted on the Gothic style to match the existing sixteenth-century wall). It can boast the largest quad in Oxford; it has its own art gallery, a pack of beagles and a choir school. Once a day the great clock strikes not the right time but its *own* time. Its chapel is the city's cathedral, and its Latin title, translated, is 'House of Christ'. (It *would* be, say some.) No wonder it commands the meadow and river as confidently as Hampton Court. The statue of the founder of both (Wolsey), incidentally, didn't arrive until 1872.

The buildings have been much altered over the centuries, particularly the nineteenth. Tom Quad was originally intended to be cloistered and the subsequent infill makes the arcading look sadly papery; the nineteenth-century battlements replace the original balustrade. The two inner towers are also Victorian and less successful than Wyatt's spectacular staircase up to the Hall.

The college consists of four main quads, each with its own scale and character: two formal and two picturesque. The entrances to these interlocking quads are subtly placed and confined by 'squeeze points', where the visitor is momentarily compressed between enclosing walls of the shoulders of buildings before being suddenly released into open and previously hidden space. This device, which was developed into the picturesque

View from Oriel Square
into Canterbury Quad

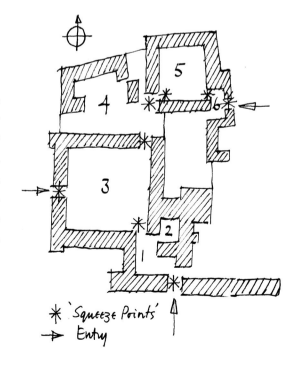

* 'Squeeze Points'
➔ Entry

landscape tradition of concealment, contrast and surprise, is masterly, and totally English in its reticence, devious planning and decent stonework. How wise of the college to make the visitors enter these spaces by, so to speak, the side door that opens off the meadows, rather than beneath Tom Tower, where the whole quad can almost be seen and comprehended from a passing taxi window. The approach from the meadows on the other hand is a beguiling series of discoveries: a lofty dark arch, mysterious vaulted ceilings, frequent turns and twists and then suddenly Tom Quad blasts off in all its authoritative grandeur. Well done Christ Church. (The back entrance from Merton Street is almost as good.)

The cathedral/chapel has grown and flowered from its twelfth-century origins as the priory church of St Frideswide; the shrine containing the relics of the saint was destroyed in 1538 and nobody knows where her bones lie. A low spire was added in the thirteenth century and the major reconstruction carried out in 1870 by Sir Gilbert

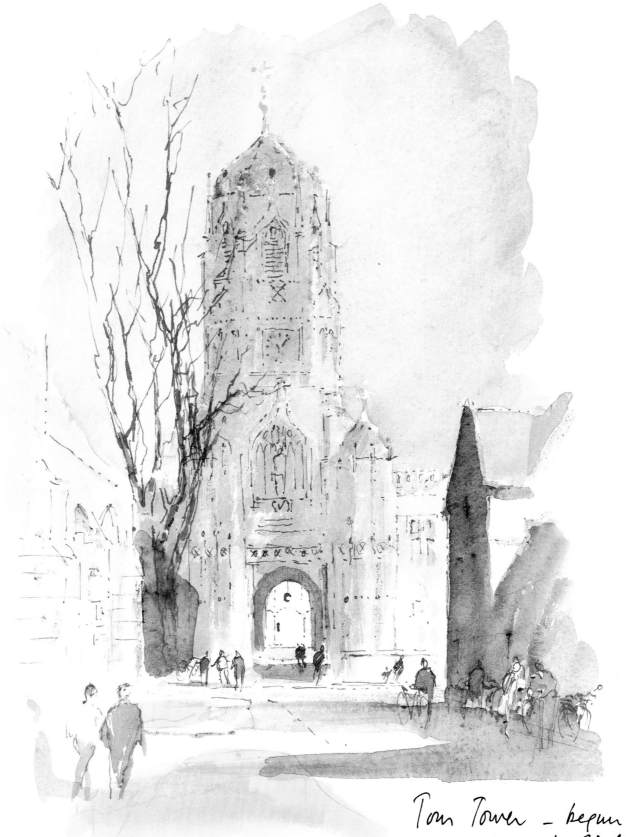

Tom Tower – begun by Wolsey
& completed by Sir Christopher Wren

A "Squeeze Point"
Peckwater Quad

The same view
looking North

Scott. The result is both bewildering and triumphant. Screens were removed, windows replaced, an extra bay built; the building was pretty odd to begin with, with bits of Norman in the choir and the triforium placed below instead of above the arches, which everywhere touch their supporting piers in unexpected and bizarre ways. The capitals are a fine set of all sorts, as varied as the furnishings – glass by Burne-Jones and Morris, a seventeenth-century organ, fine tombs and tablets and a curious sixteenth-century watching-chamber above the saint's shrine.

The Venetian Gothic Meadow Buildings nearby (designed by Thomas Deane in 1862) are grim and unfriendly; Ruskin loved them. But in contrast, the grand formality and Russian scale of Peckwater Quad manage to impress without bullying. So does the discreet Blue Boar Quad of Powell and Moya.

The most celebrated Dean to rule over this kingdom of turf and stone was Dean Liddell. A relentless reformer during his forty-three year reign, he was described by Ruskin as looking like a little red pig, and is famous to some as the co-author of Liddell and Scott's *Lexicon* (the profits from which paid for the new Deanery stair) and to the rest of the world as the father of 'Alice in Wonderland'. Alice, who was taught drawing by Ruskin, was one of a family of five; Charles Dodgson, who as 'Lewis Carroll'

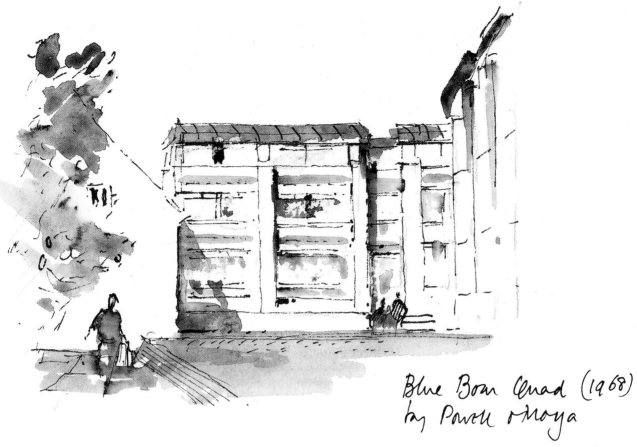

Blue Boar Quad (1968)
by Powell &Moya

was to make her famous, was a don who came to Christ Church at the age of nineteen and never left it. He was a reserved, methodical, inventive and highly imaginative man, happiest with children, for whom he had not only a roomful of toys and puzzles and games and fancy dress but an unlimited supply of that most precious of all gifts to children, time. He delighted in word play, argument and paradox, in conducting children's expeditions and theatricals and above all in making up stories. ('Tell us a story' was the perpetual cry of the Dean's daughters.) After one such expedition and story, Alice asked him to write it down. He did so. He contacted friends about publishing it, approached the Punch artist Tenniel as illustrator, and the first copy of *Alice's Adventures in Wonderland* was sent to Alice on 4 July 1865. (*Through the Looking Glass* came six years later.) By 1891 it had sold 100,000 copies. The manuscript, thanks to an American philanthropist, can be seen today in the British Library. Dodgson's posthumous portrait hangs among the great and the good in the Great Hall and, no surprise, seems to attract more attention than any other. Scholarship, after all, is not unusual in Oxford, but the power to capture for any generation the wonder of childhood is rare indeed. And it is nice that this grandest of colleges is remembered by the world as the source of a fairytale.

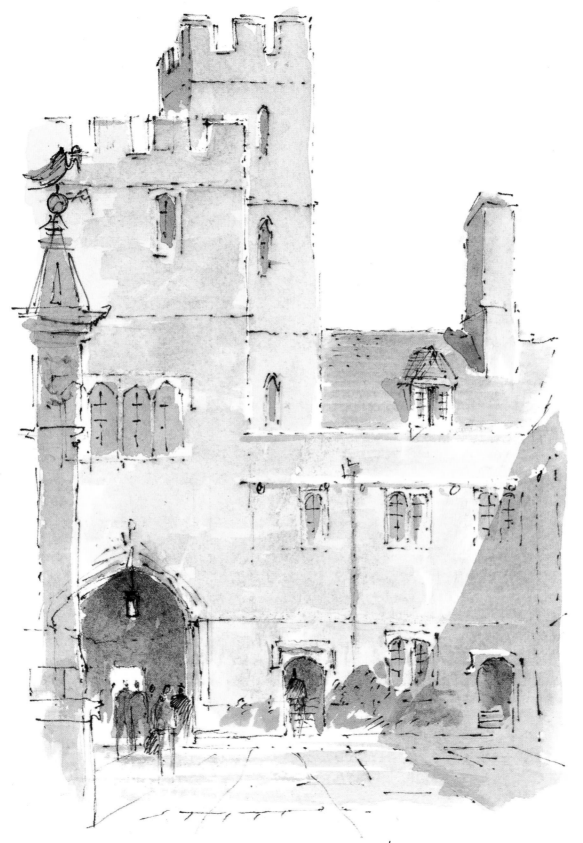

the Main Entrance from First Quad

CORPUS CHRISTI COLLEGE

Corpus Christi is larger than it looks from Merton Street, though it is said that when the blind Bishop Fox, its founder, first visited the college he was led twice round Front Quad to make it seem larger than it really was. But, large or small, it was the first 'new' college of the Renaissance, with compulsory Greek, liberal studies and a strict code of social and moral behaviour, even for the washerwomen. In 1519 Erasmus held it to be 'among the chief glories of Britain in all countries of the world', yet within twenty years it was involved in domestic rows and Presidential scandal, women, drink and bear-baiting.

In the centre of Front Quad stands the famous sundial once damaged, the story goes, by John Keble, who hurled a bottle at it. The subsequent protective railing has been removed and today it is crowned by a modern gilded pelican carved by Michael Black. To the left of the prettily vaulted entrance stands the Hall, with its original hammerbeam roof, fairly grand eighteenth-century panelling and screen, and beyond it, Emily Thomas Quad, some of which is eighteenth century but much of it sensitive and lively modern. It is flanked on the south side by the chapel, which has a restored roof and is gloomily lit but is enlivened by some pleasantly perspectivized panelling, very elegantly canopied return-stalls and a handsome screen. Beyond again, a real curiosity, Fellows' Quad, the smallest in Oxford: long, narrow, partially cloistered beneath a plaster vault and sprigged with memorial tablets. Facing it is the Fellows' Building, with eighteenth-century formality, three storeys and sash-windows, from one of which Ruskin used to gaze across the garden to the meadows beyond. The architect of cloister and building is unknown but, as so often, Dean Aldrich is given the credit. Corpus

The Cloister ... Fellows Quad

The Fellows Building — South Facade

possesses some outsiders, too. A President's Lodgings (nineteenth and twentieth century) linking the college to Christ Church and, across Merton Street, another handsome piece of T. G. Jackson.

Facing the entrance is the library: an agreeable seventeenth-century façade, behind which is an exceptionally rich library that welcomes you with patient silence, the books like dogs pretending to doze but waiting to be greeted or taken out. 'If you come to books', said a former Bishop of Durham, 'you will find them not asleep . . . they do not chide you if you make mistakes nor laugh at you if you are ignorant.'

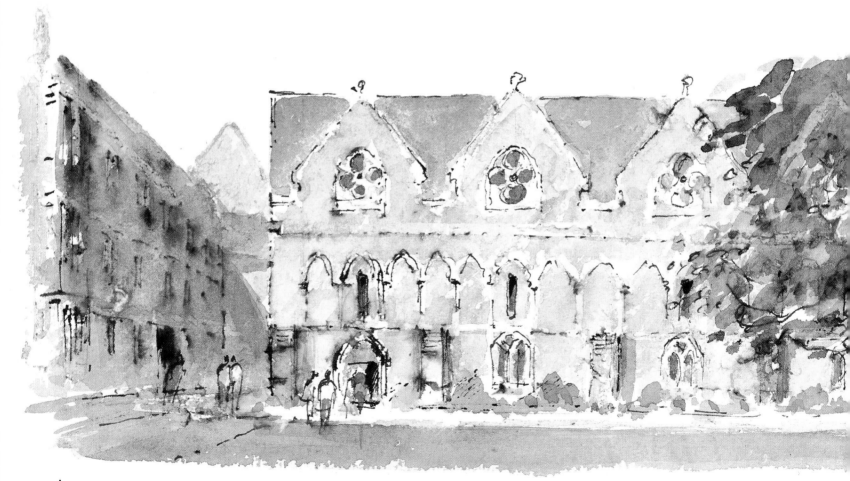

Exeter College. (East Range) over looking the Fellows Garden.

EXETER COLLEGE

By the wish of its West Country founder, Walter de Stapledon, who was to suffer the fate of so many court favourites in being beheaded, Exeter College was from its foundation in 1314 small, undistinguished, serious, conservative and poor, and behaved accordingly. (Its most expensive project during the whole of the fifteenth century, apparently, was the building of a lavatory for £4.12s.)

It was not until its sixteenth-century reconstitution, when it switched loyalties to Protestantism, that its architecture began to express its rising intellectual and financial fortunes. Exeter, in fact, passed through all the conventional stages of Oxford – medieval muddle and obscurity, eighteenth-century idleness, nineteenth-century self-regard (spiced here with muscular Christianity) – to face the present era of twentieth-century problems. But its appearance shows little sign of its switchback history. Today, from outside, the college face looks, and for the most part is, Victorian. Inside, with three notable exceptions (the Hall, the chapel, the library) the flavour is eighteenth century.

The interior of the sixteenth-century Hall (entered through an unusual 1820 porch by John Nash) invites what Clough William Ellis once described as 'first depressions on arrival'. The wood screen, columned and crested, dark and rich as chocolate cake, is handsome enough and the two Nash fireplaces are fascinating, but the light that filters with difficulty through the 'baronial' glass lacks sparkle and the timbers of the roof are ungenerously thin. All better at night, no doubt. (One of the windows, incidentally, makes amends by commemorating – an unusual gesture for Oxford – a group of distinguished artists, Edward Burne-Jones, William Morris and Reginald Blomfield.)

Across the quad, however, visual compensation erupts in Gilbert Scott's spectacular

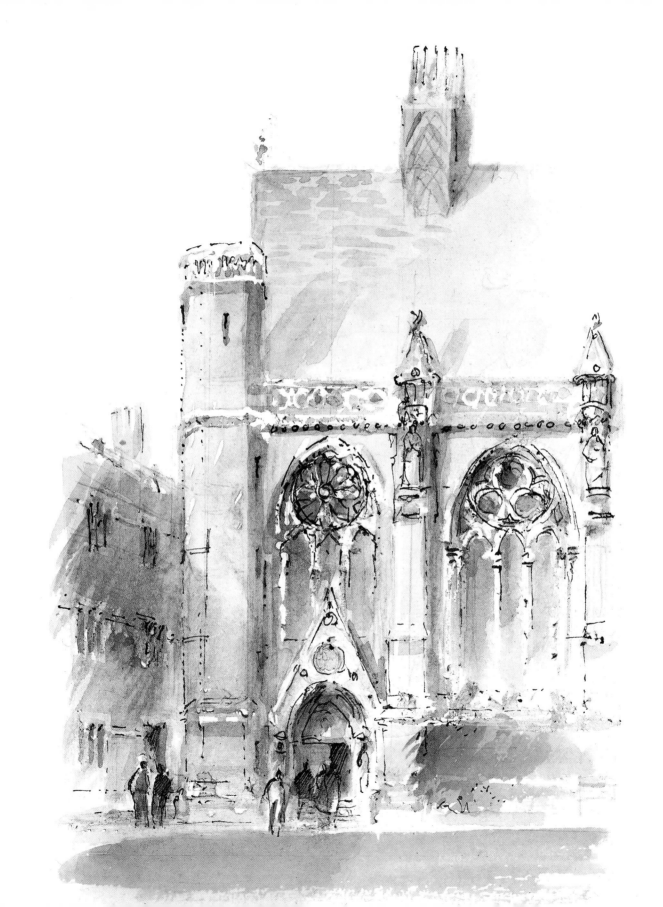

chapel, modelled on the Sainte Chapelle in Paris, and hopelessly but triumphantly out of scale with its setting (not exactly, it is claimed, where Scott originally intended it to go). If you like this sort of thing, this is the sort of thing you will like. Outside, apse and *flèche*, buttresses and pinnacles, statuary and tracery . . . and inside, not an inch of surface left unattended to – carved woodwork, multi-coloured mosaics and paving, windows as elaborately coloured as hotel stair-carpets. Embedded within all this hard-edged embroidery are two fine works of art: a pair of magnificent iron and brass gates by Skidmore and a huge and elaborate tapestry designed and made by Burne-Jones and Morris, both Exeter undergraduates.

After all this things quieten down a bit with Margary Quad – discreetly enclosed by post-war buildings of Brett & Pollen and another run of Gilbert Scott – Palmers Tower, a modest fifteenth-century relic, and finally the library looking south over the gardens. Gilbert Scott again, but this time in a relaxed and idiosyncratic mood. Surely one of his best buildings.

The Chapel by
Sir Gilbert Scott

the Stair Tower
by Sir Thomas Jackson

HERTFORD COLLEGE

This modest and complicated little college is lucky to be there at all. It began in the thirteenth century as no more than a student residence. It struggled on through the years getting the worst of intermittent quarrels with Magdalen and Balliol until in 1805 there were only two Fellows left and no pupils. In 1814 the surviving Fellow, by then a lunatic, declared himself Principal. Finally in 1820, after a serious fire, it fell into Catte Street with a great crash, and did not get firmly established again until 1874, thanks this time to the banker Thomas Baring.

Most of what you see today, therefore is nineteenth and twentieth century, and most of it is by T. G. Jackson. (You can see a portrait of Jackson at Wadham.) His style is basically Jacobean served with trimmings of French dressing, and as full of incident as the Hundred Years War. But how perceptive and imaginative of him to endow Hertford, an obscure college still tottering nervously to its feet, with two such postcard-popular eye-catchers as the Blois-type stair tower in the quad and the Bridge of Sighs over New College Lane, placed to the regular delight of tourists to join up with the North Quad, a gloomy little place with no grass and tough brick walls. Hertford is full of such Jackson ingenuities, including the handsome Palladian re-modelling of the main entrance and a second chapel alongside the eighteenth-century one, with a fine clear glass east window above a reredos by George Frampton (sculptor of Peter Pan). 'Mr Jackson', says Alden's *Oxford Guide* (1913), 'has created a very beautiful work – quite unlike anything else in Oxford.' Well not quite, thinking of 'Jacksonia' at Brasenose, Corpus, Trinity and Wadham, but fair enough.

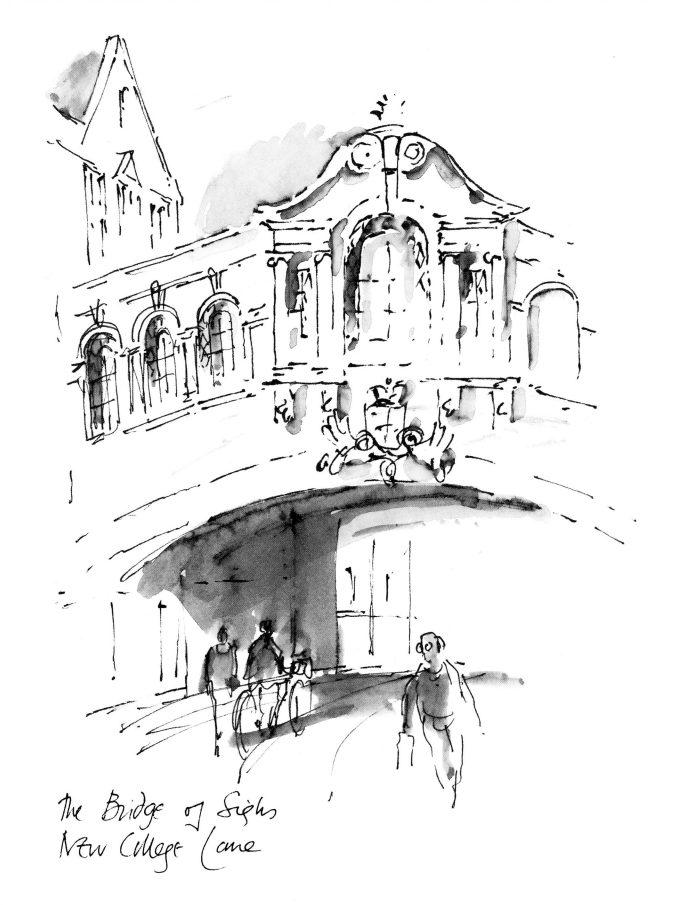

The Bridge of Sighs
New College Lane

JESUS COLLEGE

Jesus College was officially founded by Queen Elizabeth I but you might not guess this from its architecture. The library is seventeenth century, the Inner Quad eighteenth century, while much of the chapel and the Ship Street buildings, the entrance façade and gatehouse (like the front of Exeter across the street) are all Victorian and mostly pretty dull. Nevertheless, it is a compact, friendly-looking little college well suited to the sober aims of its true founder, Dr Hugh Price from Wales.

Its most conspicuous feature is not a building at all, but a giant horse-chestnut that dominates the site; its oddest, the crooked off-axis line of the path that joins the two principal quads; the most engaging, the beautiful shell door-head of the Principal's Lodgings. Bright flower-beds and curly-headed gables everywhere embroider the stone-work with movement and colour.

The chapel and the Hall are both reached from First Quad. The Hall with its busts of Queen Elizabeth and T. E. Lawrence, its age-black dragon-decorated wooden screen and plaster cartouche, is less interesting than the chapel, which was energetically restored by George Street in the 1860s. Street, the industrious hymn-singing pupil of Gilbert Scott and teacher Norman Shaw, was to become the idol of all young archi-tects. He was a follower of the 'Vigorous Movement' – plain surfaces and no projections – that had a major influence on the Arts and Crafts Movement and also on Lutyens.

Some of Street's work here, however, has evidently been regarded by the college as a bit strong, and the multi-coloured paving and marble reredos are today covered up; but the sturdy pews with their flatly modelled leafy finials hold their own and

Jesus College – First Quad

The Creeper's Door. Inner Quad

the fine eighteenth-century screen with its unusual oval openings has been left alone, and very handsome it looks too.

Beyond and past a magnificent scarred and studded door lies Inner Quad – much the same mixture as before but looking here a bit cramped and stiff – and beyond that again, a long, narrow court with a jumble of nineteenth- and twentieth-century buildings trying a bit too hard to be interesting.

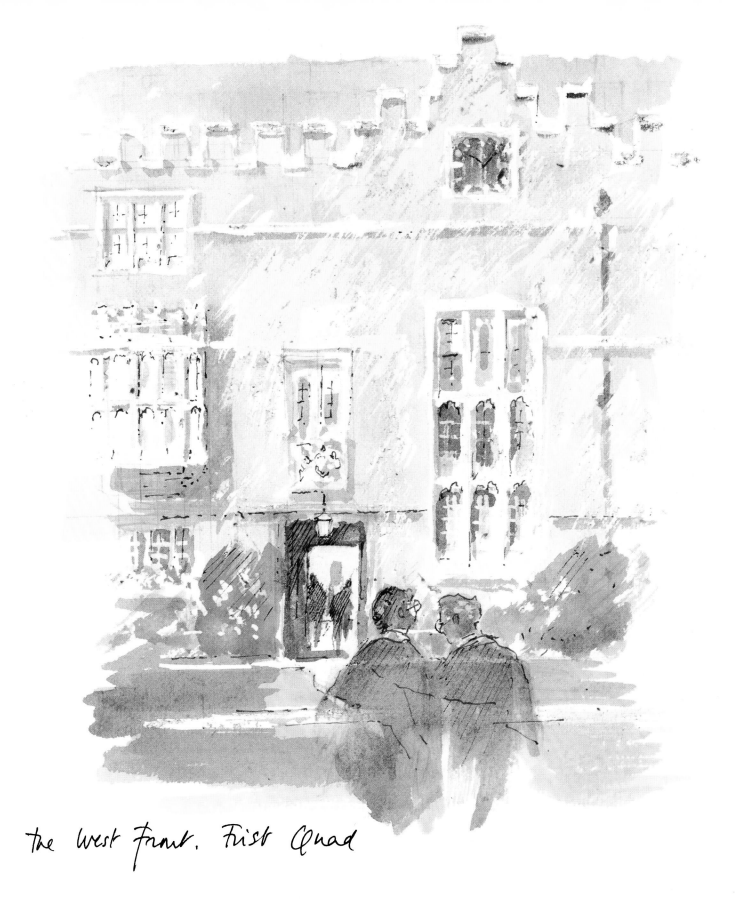

the West Front. First Quad

Keble College (1870) by William Butterfield.
The Chapel; East End

KEBLE COLLEGE

Keble College stands to its boundaries like a Christian sentinel facing the besieging armies of science across the frontiers. You needn't like it, though many today do, but there's no need to be frightened of it. True, on a November evening, it can look implacable. But look again on a summer afternoon and then the college presents a friendlier face. The brickwork, hot in colour and warm to the touch, flickers and glows. The casements glitter, the chapel pinnacles sparkle and the great chimney-stacks march reassuringly across the skyline. It shows little sign of the uncomfortably passionate commitment for which it stands, yet it must be the most single-minded building in England.

Founded to the memory of one man (a famous poet–priest), it was built to enshrine the principles and to obey the architectural rules of the Tractarian movement. Designed almost wholly by one architect, paid for by one man (William Gibbs), and built, almost all of it, at one go, it rings through the architectural timidities of Oxford like a fanfare – or more accurately, perhaps, a firebell. (It was built to disturb.)

The architect, William Butterfield, was as stern and uncompromising as his buildings. He and his architecture were one. No conciliation, no search for harmony: unyielding commitment to his principles and to structural truth. He looked like Mr Gladstone, had few friends, and kept himself to himself. He avoided publicity, wrote no articles or books, entered no competitions. The work of his assistants was brought to his desk for correction – done always in ink. No smoking was allowed in his office, no holidays except church festivals. On the site he ordered the destruction of any foliage or creeper approaching his building and had the scaffolding dusted before he mounted it.

No wonder, you may say, it all looks as it does: inside or out, front or back, the

The Library & Chapel

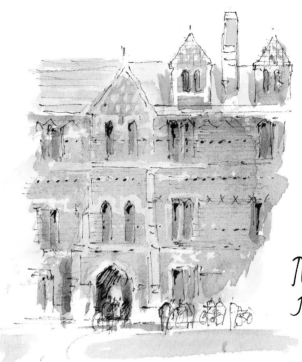

The main Entrance
from Blackhall Road

rigour and control are not relaxed. The layout is as simple and lucid as a commandment. Each side of the main entrance (unexpectedly obscure) and separated by the Hall and library block are two quads, neither of them conventionally closed. To the left, Pusey Quad, ruled over by a handsome clock-tower and softened by trees. To the right, Liddon Quad, sunken to add drama to the flanks of the celebrated chapel.

Hidden beyond stretches the Fellows' Garden, watched over its wall by unalluring science blocks, and the Hayward Quad, gracefully bounded by the glossy, curving and sharp-edged Hayward Building, another splendidly convinced building by A.B.K. Architectural Partnership, which concedes nothing but respect for its Butterfield neighbours.

The visitor is wise to keep the chapel to the last, and to begin with the Hall and the library, both reached on the first floor by a severely detailed stone staircase. The library is, for Keble, cosy. A pretty painted wagon-roof above a room divided by covered screens into 'side-chapels' lined with books, linked by a spiral staircase to the lower library, where modern, high-backed chairs echo the spirit of the nineties.

Across the landing is the spectacular Hall. Another painted ceiling, polychrome walls of brick and stone dominated at one end by a stained-glass window and at the other by a vast allegorical painting by George Frederick Watts that fits by inches the gable wall and glows richly in the shadows. Vast marble fireplaces, as Butterfieldian as the fire-irons, face each other across the tables (seating 320 people), and beneath an interest-

43

ing set of portraits — Richmond, Furse, Henry Lamb and Peter Greenham — a faint smell of gravy hangs in the air.

Downstairs again and across the sunken quad — a mistake this as it destroys the placid plane of the turf — to the side door of Butterfield's masterpiece, the chapel (never consecrated, incidentally, as this might have compromised the authority over it of the college Fellows). A contemporary critic has described the chapel as looking like a dinosaur in a Fair Isle sweater. Well, yes and no. The thick skin, the sense of weight, the woven pattern of the walls, the hint of the comic that always surrounds any human obsession is all encapsulated in this witty phrase; but it is not, in my view, the truth, which is that the chapel is indeed a masterpiece.

You expect drama and you get it. What you get also is a perfect exhibition of the Camden Society rules for church building, explored in strong forms and multi-coloured surfaces. Practical and ceremonial functions are identified, and fittings especially designed for them — the pulpit, the font, the lectern, even the brick flues. Paint was not to be trusted, so brick, stone and mosaic are used. The chief craftsman-assistant (Butterfield's favourite) was Alexander Gibbs. The light filters from on high through the lurid (and rather disagreeable) stained-glass and glances off the mosaics and the brass and iron fittings that look as if they had been made by a gunsmith. The fretworked pewbacks at first sight seem slightly Chinese Chippendale in flavour, hinting perhaps at Butterfield's one weakness, a love of Regency furniture. Passing years have softened the colours — Butterfield would have been saddened by this — and the interior of the chapel today looks almost conciliatory, the brick walls glowing softly like faded tapestry.

Presented in a specially built side-chapel is Keble's most celebrated treasure, *The Light of the World* by Holman Hunt, familiar through postcards and engravings to every middle-class home in Victorian England — and pretty mediocre it is too. There are in fact three versions of the work. This one is the first, and by his hand. A smaller copy is in Manchester and a third, probably executed by a friend, owing to Hunt's approaching blindness, is in St Paul's. This last was the one which went on a world tour of the Empire, including Canada, Australia, New Zealand and South Africa, leaving everywhere behind it a havoc of pop-star proportions — trampled grass, smashed railings, torn clothing, hysterical women. (In Australia it was seen by four-fifths of the population.)

Hunt, as cranky, obstinate and self-obsessed as Butterfield himself, quarrelled with most of his patrons, including Keble. (The college's policy of charging to see the picture was one of the reasons for doing a second version.) He believed an artist's trouble was worthy of recompense; and he took trouble. A true Pre-Raphaelite, he painted

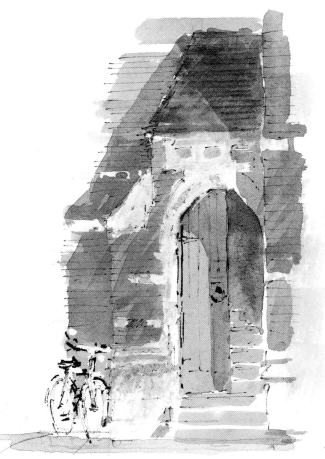

A Staircase Entrance

the picture in the open air and by real moonlight, his feet buried in straw, with hurdles to keep off the night wind. Authenticity was all. He nailed the ivy to the door, researched the design of Jesus's collar buckle and designed the brass lantern He carried. (It cost £7 to make.) For a postcard-drunk visitor to be confronted by this work, as with all celebrated paintings, is not so much disappointing, as numbing. The surface seems so polished by the passage of thousands of eyes; it sends back only your own reflection.

Out into the quad again. What is the verdict? Ruskin hated it, even giving up his evening walks to avoid seeing it. Sir Charles Eastlake said that it was ill-judged but daring; the architect Goodhart-Rendel thought that it was 'possibly one of the three or four most important buildings in Oxford'. Kenneth Clark believed it to be a masterpiece. Between the wars it was regarded as a bad joke. The wheel of fashion has now trundled it back into favour; Butterfield would not, I think, have been interested either way. He had been true to his Christian faith and to logical structure logically enriched. Such integrity, so strongly expressed and so determined not to beguile, cannot in the end fail to triumph.

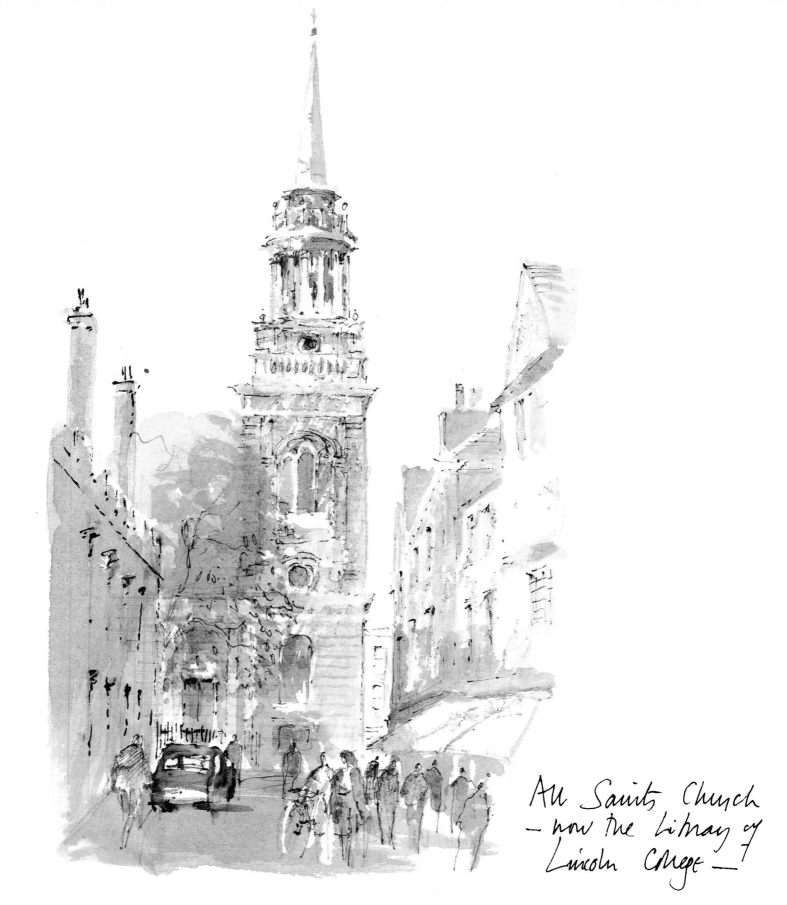

All Saints Church
— now the Library of
Lincoln College —

LINCOLN COLLEGE

Lincoln College, one of Oxford's smallest and cosiest, has changed little since its foundation in 1427. Always hard up for money and space, it lived precariously through the centuries on about one tenth of Magdalen's annual revenue, and its modest buildings, mostly two storey, were always being pulled about to accommodate new uses, rambling inconsequently through and around little courts and gardens as opportunity and ready cash permitted. The oldest bit is the street frontage (the Rector lived over the entrance with the college strong-room above him); but the Hall and kitchen (and also at one time the chapel and library) completed the Front Quad about the same time.

In Front Quad, which is much improved by its eighteenth-century sash-windows and, more questionably, perhaps, by the recent removal of its battlements, is the Hall, itself a palimpsest of architectural fashions. The fifteenth-century walls were panelled as high up as could be afforded in 1701, a flat ceiling built and sash-windows inserted. In 1889 all these decisions were reversed by Thomas Jackson. Gothic mullioned windows were brought back, the ceiling removed to reveal again the original spidery timber roof and a new and clumsy fireplace introduced. The result is a rather murky and unalluring interior.

The almost invisible portraits include those of John Wesley and Mark Pattison, the Victorian don entangled all his life in intellectual minutiae. The splendid undercroft with its fat stone pillars, and the original kitchen still crowned with its central smoke louvres, quickly restore the spirits. Behind lies the Grove, another piece of run-of-the-mill Jackson, and to the south, Chapel Quad, seventeenth-century, tiny, demure and looking older than it really is.

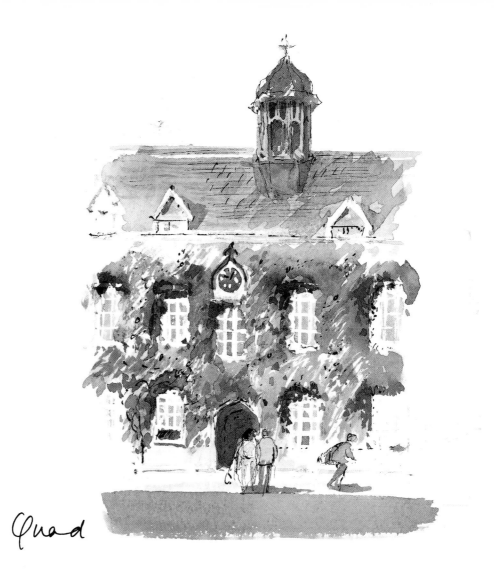

Front Quad

The chapel, a monument to increasing prosperity, makes up for the Hall. Here every surface is decorated and enriched; carved figures, heraldry, hatchments and effigies abound. The very grand east window contains a unexpected representation of the Virgin Mary at the Last Supper. But grandest of all is the library. Approached by a long, thin, winding corridor, it was ingeniously converted in 1971 by Robert Potter from the no longer needed All Saints Church which had been designed (probably by Dean Aldrich) on an almost cathedral scale. This impressive space, with its clever use of levels, is the most recent triumphant example of Lincoln's traditional skill in making use of what is already there. Never mind what Leonardo said ('Large rooms distract the mind . . . small rooms discipline it.') Sometimes space elevates and inspires, as it does here.

MAGDALEN COLLEGE

Magdalen, founded in 1498 by Bishop Waynflete of Winchester, is lucky in its generous riverside site – once a hospital's, though little remains of it – and it has used the space lavishly with that aristocratic and confident unconventionality for which the college has always been noted. (The first quad, for example, is more triangular than square.)

To walk anti-clockwise through the college is to walk through the centuries, though not necessarily in proper sequence. A Victorian entrance, then a restored fifteenth-century complex to the right (including Hall, chapel and bell tower) next to cloisters, half fifteenth and half nineteenth century, all forming an antechamber to the eighteenth-century New Buildings, anchored way out in the park, and finally back again to the entrance past the mildly interesting eighteenth- and twentieth-century buildings that stand back from the western college boundaries. It sounds a muddle and it is, but it is saved from confusion by its setting, the generosity of trees and grass, the flash of light from the river and that glorious bell tower – still more a symbol of Oxford than any other building in the University – which pins it all finally and firmly into place.

modern Gargoyles

The best approach is from the far (or London) side of the bridge rather than from High Street. The insignificant entrance porch leads into St John's Quad – not much sense of enclosure here, though the individual buildings (the chapel's west front, Bodley & Garner's President's Lodgings, the old Grammar Hall, as sturdy as a Norfolk church tower) are an engaging group. Marked by an outside pulpit, a slit entrance to Chaplain's Yard can be found – a tiny area of the kind and shape that architectural students used to call SLOAP (space-left-over-after-planning). The cloisters, reached through the Founder's Tower, were originally two storeys high and less regimented in appearance

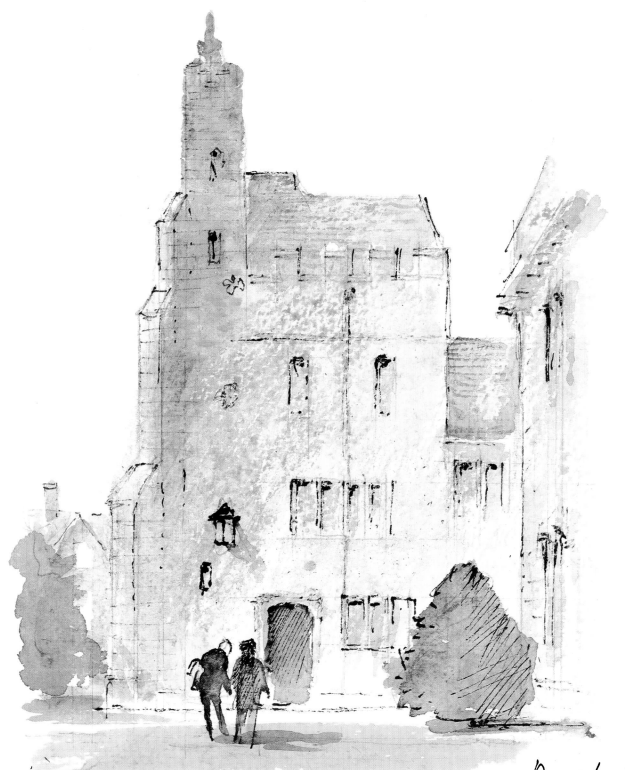

Magdalen College
St John's Quad

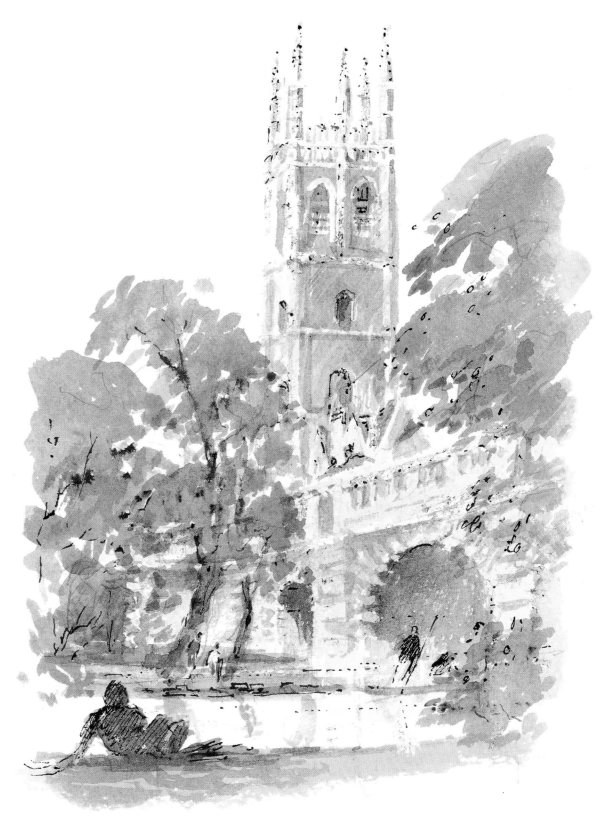

the Bell Tower above Magdalen Bridge

than they are today, but the effect of powerful buttresses marching round the square, carrying aloft their jokey sculptures, is reassuring after the casual introduction of St John's Quad, and provides a visually handsome preface to the chapel – the usual Oxford T-plan, twice restored, a nineteenth-century screen, some lively misericords and monuments. The Hall placed, as at New College, on the first floor keeps its original, linenfold panelling (including a group of elaborately carved sixteenth-century panels), a seventeenth-century screen and a nineteenth-century roof.

Separated by a broad *cordon sanitaire* of deer-dotted turf from all this medievality, real or imitative, are the New Buildings (1733), attributed to Dr Clarke with James Gibbs as consultant; their deadpan façade, sash-windowed, arcaded and pedimented stands to attention and gives nothing away. Early Victorian plans to complete the quad and Gothicize the lot were shelved. In 1822 some of the dons living in New Buildings decided that their view of the chapel was obscured by the cloister and had it pulled down during the vacation while the other Fellows were away. One, however, unexpectedly came back, stopped the demolition and insisted on the rebuilding of the cloister. The result was not liked and it was itself pulled down and replaced with a replica of the original – and quite right too.

There is a touch of Brideshead about Magdalen – the turf carpets, the dappled deer, the ancient knotted trees, the murmur of the river carrying its 'puntfuls of the fortunate', the buildings clustering like stable-blocks round the chapel tower, the complacent, commanding eighteenth-century façade of the New Buildings that seems to store the sun within its glowing stone long after darkness has fallen, and the overall sense of space, confidence and detachment.

Was it therefore at Magdalen, perhaps, that occurred that nineteenth-century University incident, when a drunken undergraduate fell to his death from an upper window? The porter woke the Bursar to report the tragedy. 'Death', said the Bursar, 'is the Dean's business' and went back to bed.

MERTON COLLEGE

Staircase Entrance
St Albans Quad

Merton Street, narrow, cobbled and cottagey, is like the back drive to a stately home. (At the end of it is the huge, triumphal arch that announces Christ Church.) Along its length runs a high garden-wall watched over by giant trees and a stretch of sunless, uncommunicative Merton College, lifelessly refaced by Blore, a deeply unoriginal architect whose façade to Nash's Buckingham Palace was mercifully refaced by Aston Webb.

But, behind all this, the buildings soon relax into a habitable humanity opening their arms to the gardens and the stretch of parkland beyond and marking, together with their neighbours Corpus and Christ Church, the very edge of Oxford itself. The college's layout is a worthy tribute to Walter de Merton, who in 1263 set up here a place of study for his eight nephews plus a few other young men who could meet the entry restrictions. These were pretty tough: scholars had to be 'chaste, peaceable and humble, dress with uniform respectability, speak to each other only in Latin and observe unity and love' – but in the founding statutes it was made clear that in the case of the Merton family these requirements should be flexibly interpreted.

Front Quad, paved and cobbled, is entered on the axis of the Hall, a virtuous rebuild, first by Wyatt and again by Gilbert Scott, of the thirteenth-century original, dominated by its steep, hard-faced timber roof. A handsome porch but the inside is not inviting. The west side of the quad is closed by the never-to-be-completed chapel, consisting of choir, transepts and tower crossing above – all an architectural experience to be hoarded to the last.

To the east is the Arty-Crafty St Albans Quad by Basil Champneys, full of charming and delicate detail, and beyond that again the gardens, some of the handsomest in

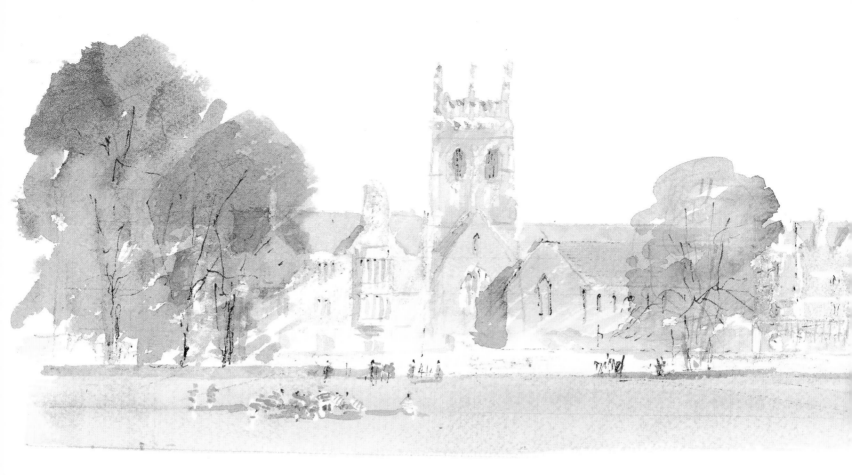

Merton College
from Merton Fields

Oxford, generously tree'd and skirted by the old city wall. Alongside, and reached by a wide Tudor arch (uncharacteristic of Oxford), lies Fellows' Quad, the earliest three-storey quad in Oxford – as formal as a doll's house, sun-dialled, corniced, chimney-stacked, sash-windowed. A delightful narrow garden bursting with flowers and hardly two paces wide separates it from the pretty boundary fence. The charm of it all is palpable. No wonder that during the Civil War Merton was a popular residence for the ladies of the Court.

Three delights lie ahead before the chapel is reached. Mob Quad, fourteenth-century and the oldest in Oxford, housing the Treasury and the entrance to the first-floor library. This presents a truly lovely interior: a low curved timber ceiling, simple oak book-shelves, reading-boards and benches, leather-bound books (here stored upright instead of lying down, as was previously the custom), colours warm and surfaces gentle to the touch. The little memorial room to Max Beerbohm is an unexpected bonus. Beyond it, the third oddity: a small, freestanding residential block by Butterfield much altered and razored over in the thirties, although inside, the staircases defiantly retain their fierce stripes.

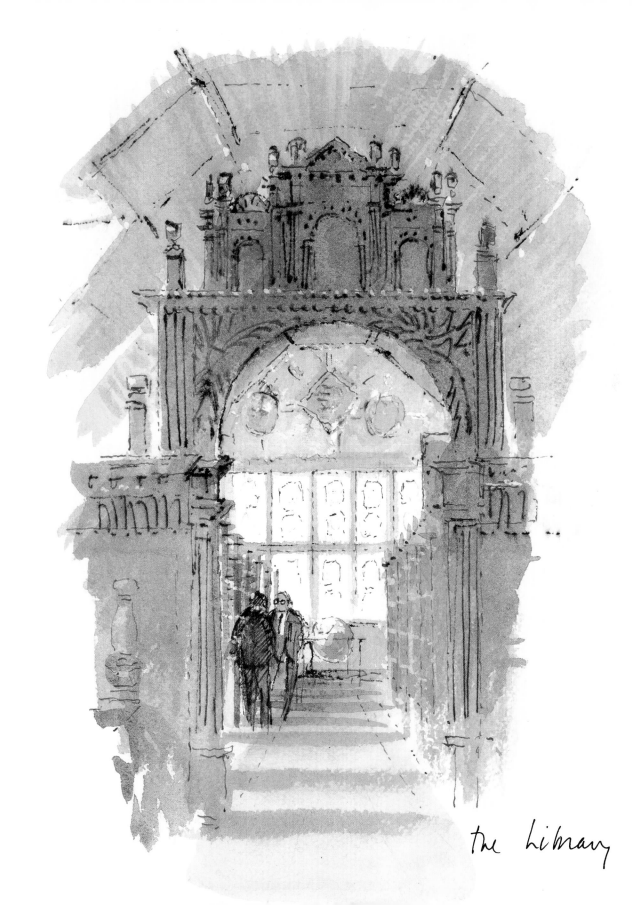

the Library

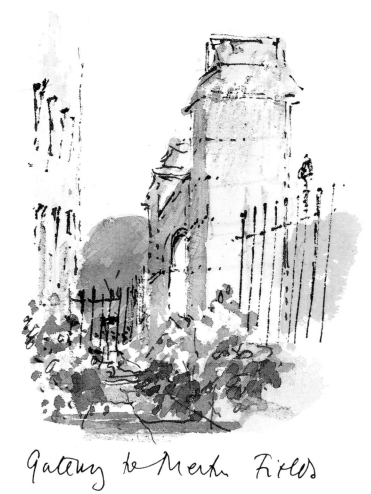

Gateway to Merton Fields

The Gardens from St Albans Quad

Finally, the unfinished chapel, to which Butterfield and Comper both contributed, is entered at the south end of the transept, presenting an interior (one of the largest in Oxford) that takes the breath away – high, spacious and spectacular. It is lined with magnificent monuments, including one to Sir Thomas Bodley, his bust watched over by the figures of Music, Arithmetic, Grammar and Rhetoric, framed between two pilasters of marble books. There is also a very odd nineteenth-century tribute in mosaic and green marble to one St Clair Woodward, murdered 1891 in India while doing his 'high, political duty'. Several brasses, a charming organ-case by Robert Potter painted in nursery colours, and two vast green marble urns, one a present from the Tsar, the other by Butterfield, complete the furnishings of this space, which is crowned by an elegant little gallery below the tower.

After all this the chapel itself, originally intended to be only the choir, is a bit of an anticlimax. A richly traceried east window, a bit squat in its proportions, lights the interior, while the handsome lectern and pulpit do their best – but in vain – to draw the eye from the glories of the antechapel, now the transept.

NEW COLLEGE

The proper title of New College, founded by William of Wykeham in 1379, is the St Mary College of Winchester in Oxford. It deserves to be called New College, however, because it was built to a pioneer design and was the first (it was rich enough) to provide within a single group of buildings the principal requirements of a college – chapel, library, Hall, Warden's Lodgings and scholars' chambers – nearly all built at one time. They lie alongside Oxford's northern city wall linked together like a long, elegant and expensive railway train confidently awaiting its first-class passengers. (The new buildings running outside the old city wall – along the suburban platform as it were – are by Gilbert Scott, Basil Champneys and David Roberts. They are a run-of-the-mill lot worth visiting only, says the college guide-book rather frostily, for the view looking the other way.)

But despite its fame and beauty you have to look hard for New College. From the north, only the bell tower and prickly silhouettes of the chapel put their heads over the parapet of the old city wall, and the main gate lies at the end of a dramatically narrow, blank-walled, shadowy and sharp-turning lane, as forbidding and thrilling as the entrance to a crusader castle. It all looks as if it had been designed by a military-engineer to repel attack. But the visitor is quickly disarmed. Instead of a portcullis, three statues – the Virgin, the Archangel Gabriel and William of Wykeham – guard the gateway, and Great Quad beyond (though not helped in its proportions by an extra storey added later) presents a friendly and impressive grandeur.

High-quality visual rewards lie behind and before. First, the cloister, straggling back along the side of the entrance lane just traversed, a peaceful, empty, silent enclosure,

the old city wall

The Garden Court & wright. war screen
seen from the Gardens

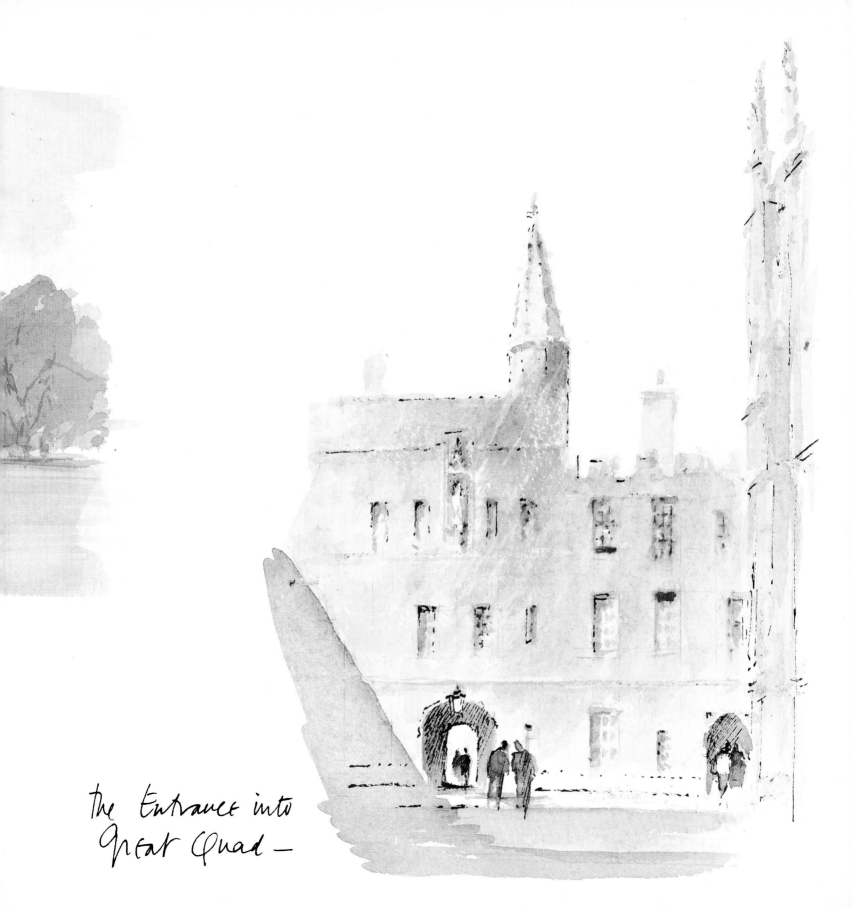

The Entrance into
Great Quad —

The City wall
flanking the Gardens

almost unaltered (except for roof timbers) since its medieval construction. A bell tower stands sentinel (who could guess there is a small pub at its feet outside the college wall?), a single chair rusts away under a great ilex tree. Fine monuments (one lettered by Eric Gill) adorn the walls. There never seems to be anybody there. Perhaps its contemplative serenity disturbs the conscience.

Amends are richly made in the adjoining chapel and Hall. Both antechapel and chapel are lofty, but, as at Merton, the antechapel wins on spectacle – due almost entirely to the huge painted west window, made in 1778–85 to a design by Sir Joshua Reynolds. This vast transparent painting (faulted only by a Victorian re-arrangement of the central tracery), in warm swirling colours, has, like Epstein's great figure of Lazarus standing below it, survived its critics. Both live on triumphantly. The chapel, heavily restored by Gilbert Scott, is entered beneath the organ. Here the visitor finds eighteenth-century glass, some lively misericords, clumsily-placed stalls, canopies, and a dreadful reredos – but two treasures revive the spirits, the founder's crozier and a painting of St James by El Greco.

The adjoining fourteenth-century Hall (with another Gilbert Scott roof) is reached up a long flight of steps and offers Victorian glass, magnificent sixteenth-century linen-fold panelling and a fine portrait by William Nicholson of H. A. L. Fisher. The last delight lies ahead.

Through seventeenth-century Garden Court – spreading, sash-windowed and battlemented – lies the famous garden, often claimed to be the most beautiful of all Oxford's

The Bell Tower

celebrated gardens, veiled from immediate view by a handsome eighteenth-century wrought-iron screen by Thomas Robinson. It was originally laid out for profit – vegetables, apple trees and vines – rather than for pleasure but from the start it possessed two splendid features, the old city wall, which formed two of its boundaries and is still preserved to its full height, and an artificial mound built in 1590 with a summerhouse on the top for observing the view and steps and hedges arranged in formal support. Sadly, only a remnant of this elegant artificiality remains – the passion for the picturesque was to follow – and lovely and treasured as the gardens are today it would be nice perhaps to see the mound reinstated even if the view over the wall is nothing to write home about.

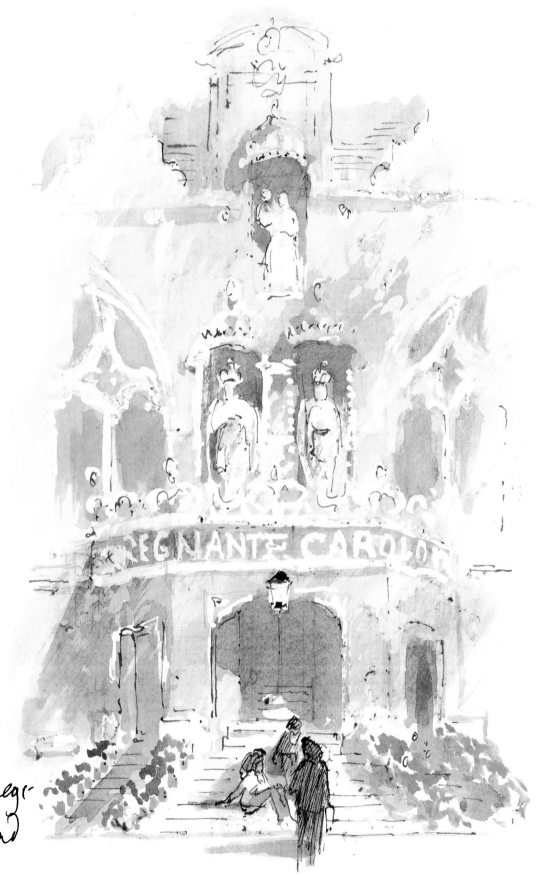

REGNANTE CAROLO

Oriel College
Front Quad

ORIEL COLLEGE

Oriel, long and straggly, links High Street with Merton Street. Originally there were two colleges on the site: Oriel College and, at the High Street and older end, St Mary's Hall. In the sixteenth century there was no passage between the two, but in 1902 they were united and today the one-time entrance to St Mary's from the High is usually closed.

Front Quad at the Oriel end is largely seventeenth century. It is much the same inside and out, except for the central projecting porch, rebuilt in the nineteenth century, which has steps and a crest of open lettering providing a dais for the two statues of Edward II and Charles I, crowned, orbed and sceptred, and very self-conscious too. On either side of the porch stand the Hall and the chapel, with the same elegantly traceried windows for symmetry. (Even the bays are repeated, unwanted and awkward in the chapel.) Both interiors are commendably simple, sober and mutually supportive. A hammerbeam roof spans the Hall in which the panelling and screen are both the work of J. N. Comper, while the chapel ceiling is painted boarding above panelling and stalls with handsome ball finials, all very like Corpus. The organ case is by Jackson and the gallery in which it is placed is worth the climb to visit the memorial by Richard Westmacott and the loosely treated colourful nineteenth-century stained-glass window moved here from the eastern end. (The two tablets, one to John Hughes, assassinated in East Africa in 1914, the other to William Stone, who died in the Crimea after a brief life spent in useful and honourable exertion, are reminders of Oxford's one time leaning towards public service.)

Leaving Front Quad and walking north you come first to Back Quad, small, shadowed

Gabled Staircase Door

by huge trees and dominated by the classical façade of James Wyatt's library built in 1788, with its rusticated ground floor and sash-windows, formal and chilly. Then, through a twisting little ramped alley-way to the side you come into St Mary's Quad (with relics *en route* of St Mary's Hall and chapel) and the mood changes again. To the left, a decoratively treated Gothic Revival façade, to the right an eighteenth-century version of half timbering – each delightful in its own way – and across the back, the Rhodes Building (he paid for it) incorporating the old gatehouse to High Street. The architect is Basil Champneys, as usual in playful mood. A young copper beech tries to keep order among all these high spirits.

PEMBROKE COLLEGE

'Very indifferent and ill-composed', remarked a discourteous eighteenth-century travel-ler. He was speaking, of course, of a group of sixteenth- and seventeenth-century build-ings which have today ceased to exist, having been re-modelled, extended, refaced or obliterated by later hands. What we see today is largely nineteenth century . . . and none the worse for that, either. Nevertheless, Pembroke's position up a cul-de-sac and on the fringes of central Oxford (its south boundary is the old city wall) has helped to push it out of the tourist stream of guidebook gush. Undeservedly, for once through its least attractive feature (a much re-worked gatehouse) there is a good deal to enjoy within its walls.

Old Quad, the first to be encountered, is small scale, with cottagey-tiny windows balanced over flower-boxes and steep roofs pinned into place by sturdy chimneys. To the east lies the oldest bit, Wolsey's Almshouses, a picturesque huddle converted today into the Master's Lodge. (Jan Morris recalls a famous couplet of 1864 concerning two candidates for mastership, Price and Evans:

> We won't have Evans at any Price
> And as for Price, O 'Evans

In the event Price succeeded Evans so they had both.)

To the west, Pembroke's show-piece, Chapel Quad, is dominated by the Hall, the chapel and an impressive range of Victorian rooms. The Hall, a strong and graceful building both inside and out and reached up a handsome flight of steps, was designed by John Hayward. Outside, the chapel is dullish classical but inside it is of a magnificence

Garden Door
from Chapel Quad

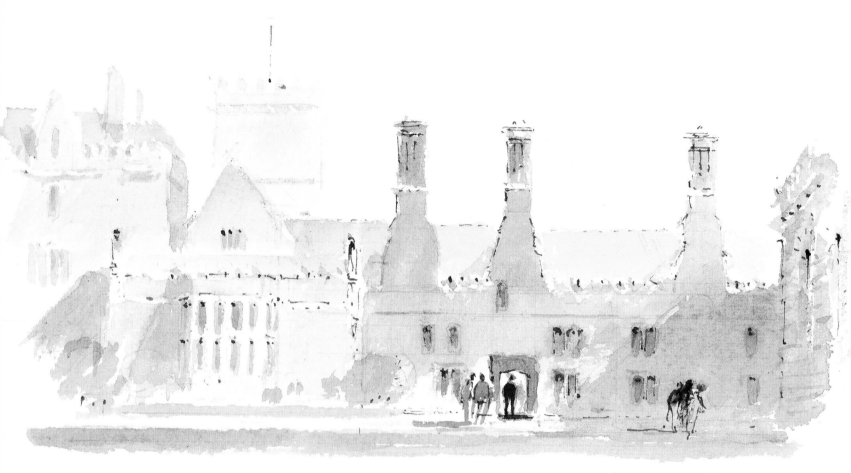

Chapel Quad ..
The East Range

only Ruskin could deal with. Once through the original eighteenth-century screen the interior explodes before your eyes like a firework display – marbles and inlay, mosaics and gilded ironwork, carvings and panelling . . . dark green, rose pink, cloud blue . . . sparkling in the greenish light of the stained-glass windows. Over the marble altar, and framed in marble columns white and blue-veined like thighs of a goddess, is a Rubens copy. All of this is the work of C. E. Kempe, the prolific and successful designer of stained glass who here extends his skills into three dimensions with such success that it makes us wish he had done so more often.

Outside and across the quad, behind a range of Victorian buildings (also by John Hayward) lies North Quad, a recent development in which the college took over an agreeable terrace of houses in Pembroke Street, turned them back to front, inserted a couple of new buildings and paved and planted their old back-gardens to make North Quad: an ingenious and attractively designed project to match the similar exercise at Wadham.

Some colleges are better known for their famous inhabitants than for their architec-

Chapel Interior

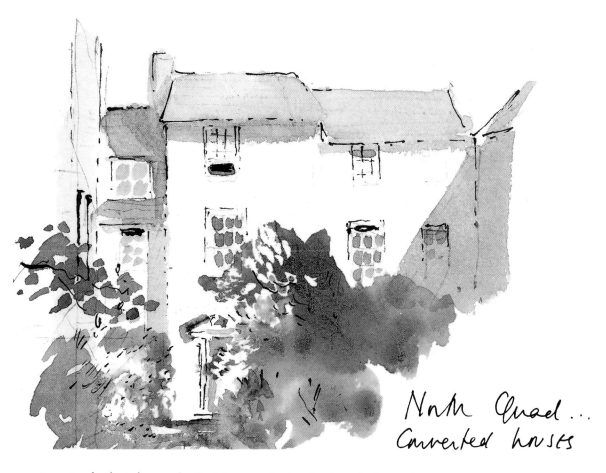

North Quad...
Converted houses

ture. Pembroke is famous for Dr Johnson, who lived and worked over the main gateway and left without a degree (an omission later to be rectified by an admiring college). Despite his painful poverty he enjoyed himself and enjoyed, too, returning often in later life – though, as he told George III, he was always glad to get home again. His association with Pembroke is remembered by a Reynolds portrait, a Bacon bust, a couple of writing-desks, a pile of papers, a host of anecdotes and a teapot, but his shadow falls everywhere.

Pembroke deserves more praise for its buildings, lively or modest, than it usually gets. John Betjeman called it 'shy' and wondered why it was that 'it seemed to have more character than Queen's or Univ: so splendid in the High'. The answer lies, perhaps, in its lack of physical grandeur and the unaffected way it expresses a sense of service to scholarship.

THE QUEEN'S COLLEGE

Front Quad –
The West Arcade

The queen was King Edward III's Philippa; the founding in 1340 was by her chaplain. But nothing of all this remains above ground. (The entrance was moved and even the queen under the cupola over the gateway to the High is another one.) In fact, although older fragments remain in the North Quad, virtually everything to be seen was built between 1672 and 1765.

Sir Christopher Wren is usually credited with lending a hand and a consultant's eye during this busy rebuilding, though not apparently with the spectacular library that divides North Quad from the Provost's Garden (the arcaded ground floor was originally open to both). The architect of this building is unknown but the result was regarded as so successful that it prompted the rebuilding of everything around it (out of embarrassment with its shabbiness). The interior upstairs is magnificent – a garlanded frieze, a richly decorated ceiling, handsomely carved bookcases – watched over by figures of Arts and Science commanded by a wooden statue of Queen Philippa. A lovely room to visit but perhaps too powerful to work in.

Gradually the rebuilding moved south into Front Quad, changing slightly in character as it went. The east and west wings are severe and almost military in their tough simplicity. A rusticated and pilastered screen supports a central and domed gatehouse, providing the focus of one of the most famous views in Oxford. (The queen under the rotunda, incidentally, is Queen Caroline, who paid for much of the work around her. Considering Oxford's long reputation for misogyny it is surprising how often women are celebrated in painting and sculpture for their patronage, generosity, and piety.)

Front Quad.
The Gatehouse

Brawda Buildings

Provost's Lodgings 1958
by Raymond Erith

Scholars differ as to who designed the Front Quad but Nicholas Hawksmoor, Christopher Wren's pupil, usually gets the credit, as also for the chapel and the Hall (to which college members are still summoned by a silver trumpet). These fine rooms placed end to end (as at University College opposite) are on a triumphant scale: a barrel-vaulted ceiling, giant pilasters and contemporary woodwork in the Hall, a full-height apse in the chapel rising to a coved and decorated ceiling by Thornhill. 'Remarkable in their way', grudgingly observed a visiting clergyman in 1820 of all this starry splendour. And if it is found a bit overwhelming there are two areas of contrast to be discovered: the Provost's Lodge, a beautifully understated piece of twentieth-century Georgian by Raymond Erith, with its jumble of outhouses and trellised sheds, and next to it a sensitive re-modelling of some old houses in a silent sunny corner of the precinct. Remarkable in its way, for that matter, is the college's Florey Building, a shiny, scarlet-faced and glittering essay down by Magdalen Bridge, designed by James Stirling — as visually disturbing as Keble must have been a century ago.

ST EDMUND HALL

Short on glamour but long on charm, St Edmund Hall, which did not become a college till 1957, was the last of the medieval halls (each a group of students under a Master) that preceded the college system. It is engagingly tiny, its main entrance hardly bigger than a domestic front door, and the sixteenth- to seventeenth-century quad it serves (where the original well is still working) is as cosy and friendly as a private garden. The modern additions beyond are lively though a bit tough on their neighbours. In addition the college possesses two curiosities worthy of exploration.

First is the curious little classical stone-faced doll's house that has been inserted into the façade opposite the entrance, with pediments, mullions, elaborate cornices (one resting on two piles of stone books to denote the use of the upper floor as a library). Beneath is the chapel, with early glass by Burne-Jones and Morris and an adventurous altar-piece by Ceri Richards.

The second curiosity is the ingenious and sensitive conversion of the adjoining little church, St-Peter-in-the-East, to a new college library. Seats are scattered about under the trees, birds sing, shadows dapple the headstones, distant traffic hums like a water-wheel. It would be hard to find in Oxford so peaceful and sheltered and Millais-like a setting for study.

Such a modest institution never attracted the famous or the smart but the eighteenth-century antiquarian Thomas Hearne, through eleven volumes of his notebook, is still endlessly quoted partly because he was always so personally and entertainingly rude and partly because of his belief that, when laudable old customs alter, it is a sign that learning dwindles – a principle established upon hearing that there were to be no fritters at dinner.

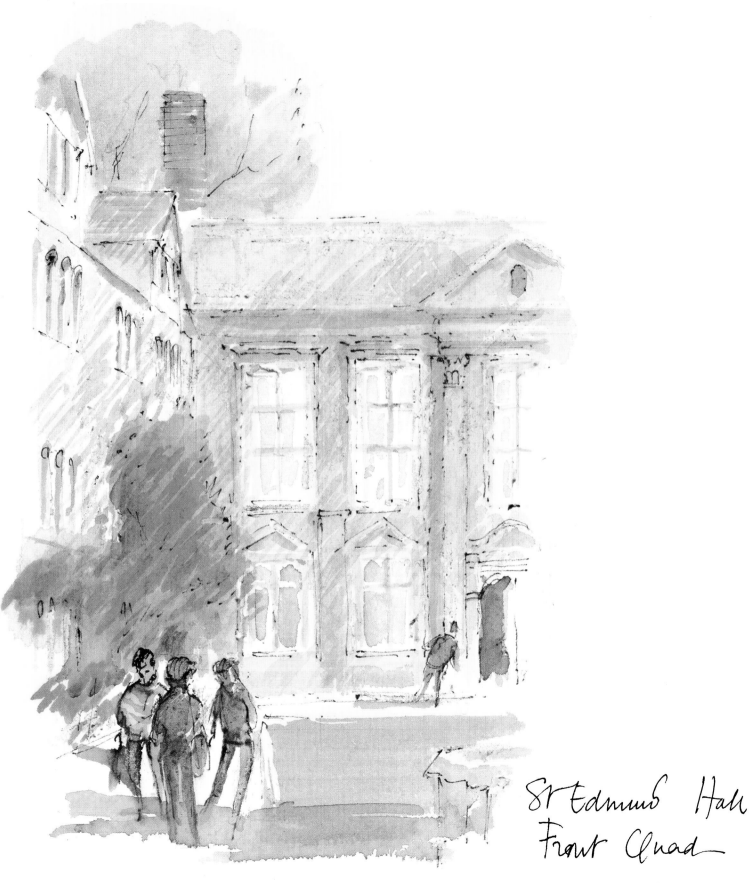

St Edmund Hall
Front Quad

St Peter's in the East – now the Library

St John's College - The Old Library (1596)

ST JOHN'S COLLEGE

There are four entrances to St John's (though the back door to Trinity makes it look like five). To look at they seem to symbolize the architectural variety they conceal. Almost hidden, too – and luckily perhaps – behind a row of fine trees, are the long, rather boring street façades of various dates. But glories lie within.

The Front Quad is formal. To the left, the chapel: to look at largely nineteenth century, with its thin woodwork, curtained glass and burden of fine monuments – urns, skulls, heraldry, a spectacular gilded and garlanded lectern and a touching memorial, rare in Oxford, to two small children aged five and a half and seven. To the right and across the central passage is the Hall, largely eighteenth century, with a chilly stone screen by James Gibbs, a good fireplace and a magnificent portrait of Sir John Case clasping his book of medieval medicine; a skeleton grins at his feet to remind him presumably of medical fallibility.

A trim carpet of green turf is spread over the centre of the cobbles. It's a strict start but richness and generosity lie waiting. First, Canterbury Quad elegantly expressing the Royalist and High Church leanings of the college. (Archbishop Laud paid for it. Charles I and Henrietta Maria – their statues stand over the entrance gateway – attended its opening.) It is a beautiful space. Arches measure and step out the boundaries. Carvings and sculpture embroider its hem. Through the narrow gateway lies the second treasure of this fortunate college, its famous garden, middle sized but, due to the skill of Humphry Repton and Capability Brown, apparently without limits. Winding paths, carefully placed trees, elegant seats at strategic points alert the eye and awaken curiosity. Across the west boundary the long, low library wing stretches lazily over the lawn

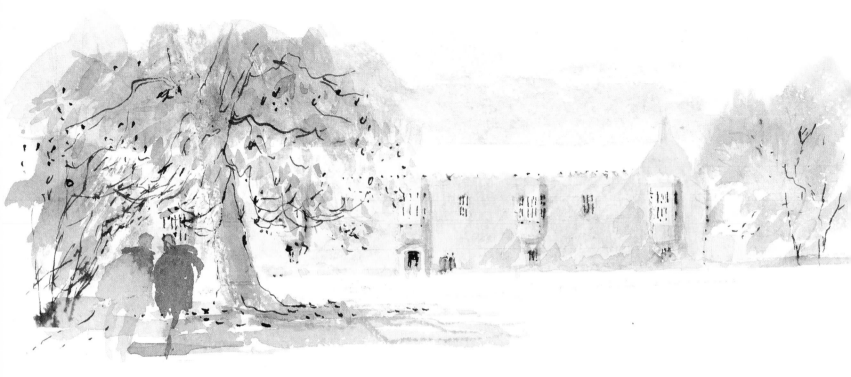

Canterbury Quad from the Garden

like a sleeping, sun-struck sandy-coloured cat. Over the north wall two excellent modern extensions by the Architects Co-Partnership and Ove Arup and Partners crisply command their quiet quads. The third glory is the library interior, long, L-shaped, one wing of it covered by a striped ceiling of timber and plaster that hovers protectively over the bookcases and benches of blackened oak. The readers seem suspended, weightless in space and time.

And if you find the walls of stored knowledge oppressive there are three curiosities that inject reality into this unworldly place: a Parliamentarian cannon-ball picked up by the city wall, Archbishop Laud's blood-stained cap picked up on the scaffold, and a portrait of Charles I executed in handwriting. It is said that Charles II so admired this that he asked to be given it in return for the granting of any college demand. The college agreed. 'Your wish?', asked the king. 'Give it back, please', they replied.

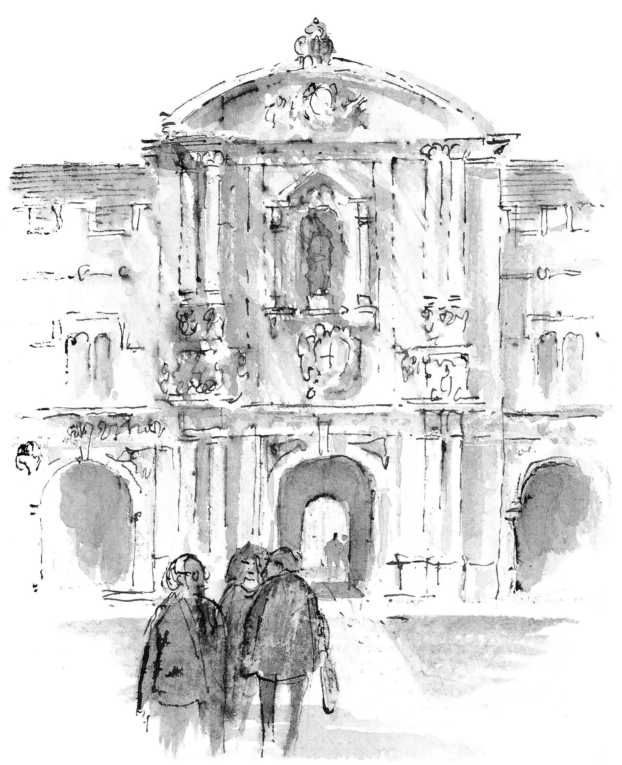

Canterbury Quad. The West Doorway

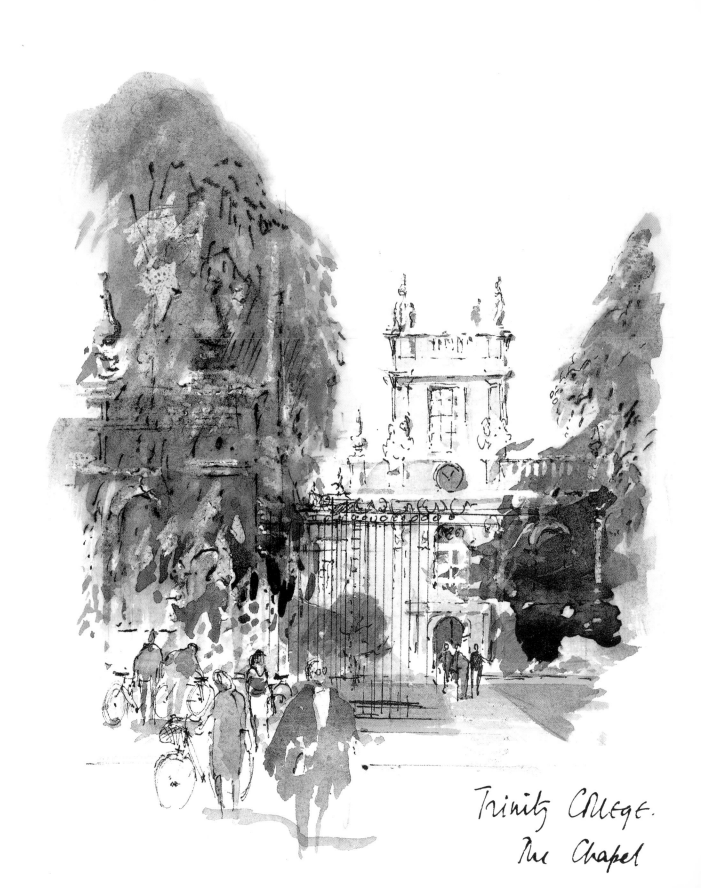

Trinity College.
The Chapel

TRINITY COLLEGE

Durham Quad
A Doorway

Most Oxford colleges toe the line of the street. Trinity does not. It stands well back from the surrounding streets looking among its lawns, outbuildings and huge trees like a country house in its own park. Not surprisingly, perhaps, it is (or was) a college traditionally popular with the young landed gentry, who found the look of the place familiar and congenial. The best view of it is through the splendid great gate piers opposite Wadham in Parks Road. This gate, however, is a cheat. It does not open, and you have a long walk round to the Broad to reach the proper college entrance, where similar gate piers reappear, towering above the tiny cottage lodge. First impressions to those peering through the ironwork (these gates are unused too) are as mixed and agreeable as the buildings themselves.

To the right is a pair of cottages, a seventeenth-century stone manor house and some rather overbearing modern buildings, courteously screened by Thomas Jackson in a heavily gabled mood. To the left Waterhouse and Butterfield gaze sternly from Balliol over the garden wall. Ahead lies the old gatehouse tower (the original approach lane has vanished) carrying aloft the figures of Astronomy, Geology, Theology and Medicine (they are too highly placed to see which is which). Across the end of the quad is the chapel looking very trim and handsome, even metropolitan, in its seventeenth-century livery, adorned with urns, balusters and heraldry. Christopher Wren, some of whose drawings for Trinity still survive, was consulted about and approved the design – and no wonder. It must be one of the most handsome, complete and unaltered seventeenth-century church interiors in the country. A finely modelled and painted ceiling, beautifully detailed stalls, a carved screen and inlaid panelling in

juniper wood, and two splendid recumbent effigies of the founder and his wife: Sir Thomas Pope, a wealthy civil servant and friend of Mary Tudor, would not have been worried by the worldly scenery in which he lies.

Across the quad is the modest Hall, with painted eighteenth-century panelling — a pleasant change — and some interesting portraits. The north side of Garden Quad, by Wren but much altered, opens up to wide lawns and dreaming trees stretching away to the college boundary. The country house atmosphere persists. You would not be surprised to hear the clink of a stable bucket or cries of 'sorry' from a tennis court behind the pleached limes.

Yet not so long ago this tranquil setting was the background of a violent theological storm, the Oxford Movement, launched by the charismatic figure of John Henry Newman. He had entered Trinity at fifteen. In 1833 he had written *Lead Kindly Light* while becalmed in an orange-boat off Palermo. He arrived to achieve the spiritual revival of the Church of England. The debate aroused such passion that in 1844 it was proposed that the movement be publicly condemned by the University. Feelings ran so high that on the night of the debate two academics walked through a snowstorm from Swindon in order to be present. The motion was defeated but Newman left Oxford, joined the Roman Catholic Church and eventually became a cardinal. 'Never again', he wrote enigmatically, 'have I wished to see again a place which I have never ceased to love.'

UNIVERSITY COLLEGE

Garden Wall.
Radcliffe Quad

To the pedestrian walking down the High the sunless flanks of University College (generally known as Univ) seem to stretch out for ever. A tablet recording the place where Boyle's Law was invented – hands up those who remember what it said – and a couple of fan-vaulted gatehouses each sporting a statue of a queen, are the only interruptions in this austere procession of gables and casements which replaced the original medieval buildings and are repeated unchanged around the two quads within. But there is more than meets the eye there as, although the façades seem continuous, half their length is seventeenth century and the other half a century later, surely one of the earliest examples ever of 'keeping in keeping'.

Symmetrically placed opposite the main entrance into Front Quad are the Hall and the chapel, separated by a passage-way beneath a nineteenth-century oriel window designed by the Master of the college at the time. (Masters these days seem rarely to be seen at the drawing board.) The Hall, twice re-modelled since the seventeenth century, is lofty and gloomy, the dark wood looking better at night. But the fireplace (1904) is a fine piece of Cunarder swagger and there are some interesting portraits. The chapel across the passage is even gloomier (spirits are not raised by Gilbert Scott's flaccid corbels, timber roof and the garish stained glass), but the carved and pillared classical screen restores our confidence and sits well with the three Flaxman monuments in the antechapel. The largest and most ambitious of these depicts in marble relief Sir William Jones, the Orientalist, seated before a group of admiring and respectful natives and writing his digest of Hindu law. Palm trees rattle their metallic petticoats behind him and musical instruments from east and west crown the composition.

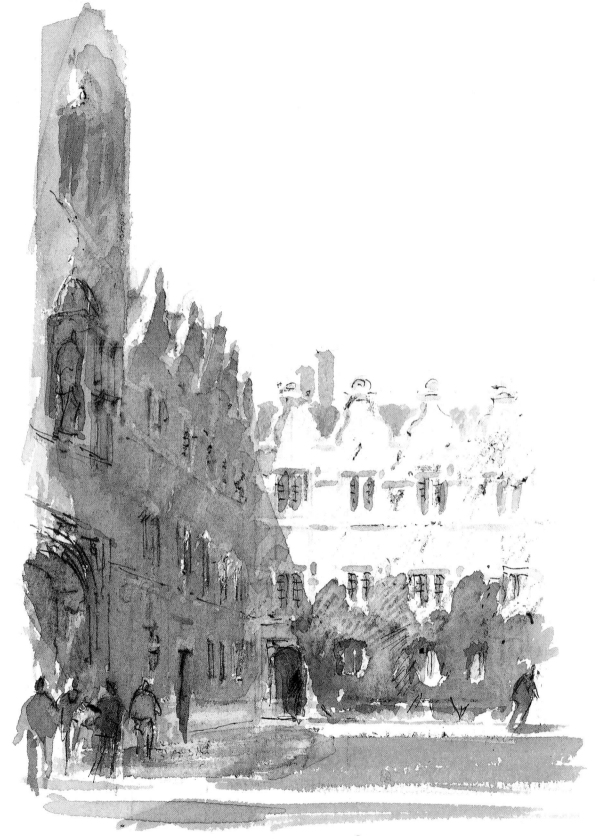

University College. First Quad

The Shelley Memorial
by E. Onslow Ford (1893)

Behind these two college centrepieces is the library – Scott again, but this time in a rather jokey mood. The room has been horizontally divided and painted white (a great help), and the saucy tracery of the west window is by A. G. S. Butler (1937). Odder still are the two gigantic seated statues of Lord Eldon and Lord Stowell, who guard the entrance door with marble disapproval. (The group was intended for but understandably refused by Westminster Abbey.) Behind again a small and ingenious modern block of accommodation and the college service yard.

To the east lies the Radcliffe Quad, which is ruled by the statue of Dr John Radcliffe – quite rightly as he paid for its building. (His statue cost nearly twice as much as Queen Mary's the other side of the gate.) Radcliffe is one of Oxford's most famous figures, a wealthy physician who presented the University with a library, an observatory and an infirmary, each one of them a fine piece of architecture. Here he wears a soft cap and his staff is wreathed by a serpent. His head is cocked enquiringly towards the east and his proprietorial gaze looks over the wall into the Master's garden, straight into the mullioned windows of the Master's Lodgings – a Hollywood version of a Cotswold manor house designed by G. F. Bodley in 1879 – and towards the Goodhart Building (1961, not a success).

The college straggles on. To the west the beautifully tree'd and informally designed Fellows' Garden, at the back of which can be discovered behind a wrought-iron screen an unexpected treasure, the Shelley Memorial, a small domed and columned chapel by Champneys containing the lusciously modelled full-size figure of Shelley as he was found on a Ligurian beach: a white marble corpse lying like a dropped linen sheet supported on a richly designed bronze pedestal and the Muse of Poetry herself. Above hovers a Cambridge-blue sky, around its horizon a couplet written in gold upon sienna-brown walls. The sculptor was E. Onslow Ford, who trained in Belgium and Germany and whose works include many figures entitled Peace, Fasting, Music, Applause and also Dr Jowett's bust at Balliol. This work, presented to the college by the sculptor, is a top-rank high Victorian stunner.

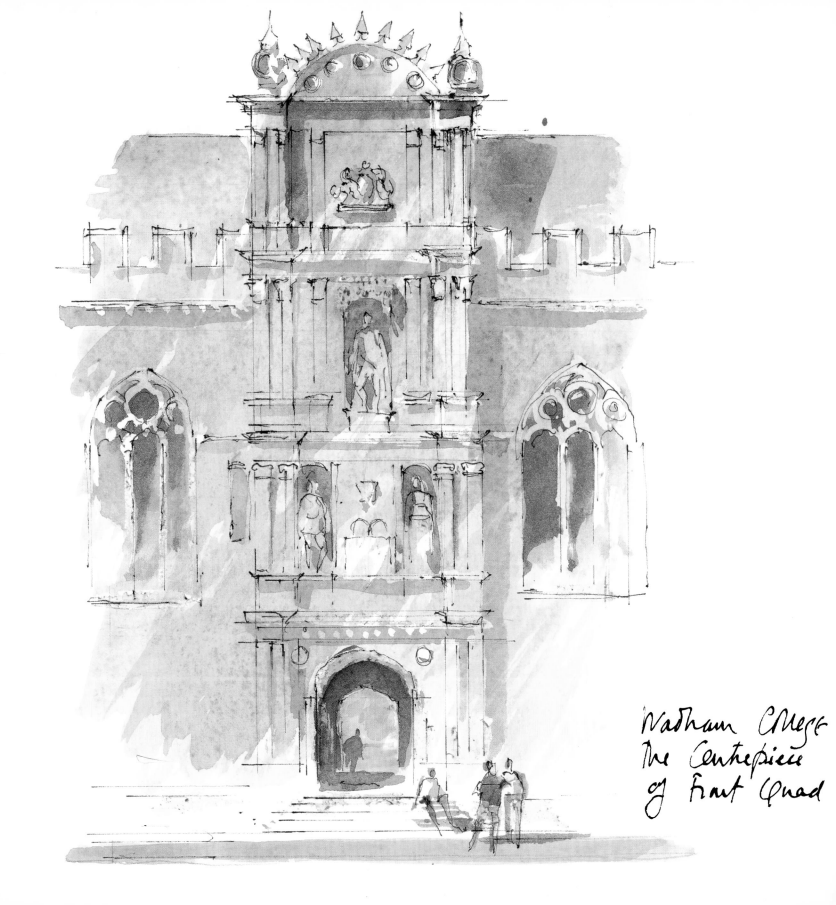

Wadham College
The Centrepiece
of First Quad

WADHAM COLLEGE

Wadham was founded in 1610 by Nicholas and Dorothy Wadham from Somerset. The architect–mason was probably William Arnold, who managed to get it built all at one go. Its historian was the architect Thomas G. Jackson, RA, baronet, scholar and Fellow of Wadham, who during his professional life can be said to have changed the face of Oxford in his particularly free Jacobean style. (He also built at Uppingham, Rugby, Westminster, Radley and Eton, designed embroideries, altar silver and an inlaid piano, a campanile for Zara in Dalmatia and a barge for Oriel, while also finding time to save St Mary le Strand and St Clement Danes (threatened by road widening), to write and illustrate a number of books, and to reorganize the Royal College of Art.) The pink and bearded face that peers mildly from its frame in the college Hall – the portrait was saucily removed after the last War, when his work was temporarily out of fashion – carries no hint of the driving energy and physical stamina so characteristic of successful Victorian architects. Needless to say, Jackson rowed for his college and, of course, when leaving the University rowed himself away down the river to Reading. When aged 68 he sculled from Oxford to London and personally fixed the weathercock on the spire of St Mary's, which he was restoring. His only work at Wadham can be seen in the chapel and Warden's Lodgings, and in the charming little first-floor conservatory by the entrance gates.

William Arnold has done his work well. The design of the Front Quad is obsessively, if in places falsely, symmetrical, with its coupled columns, niches and statues – professionally capable rather than beautiful – and with its Edwardian overmantel-type enrichments.

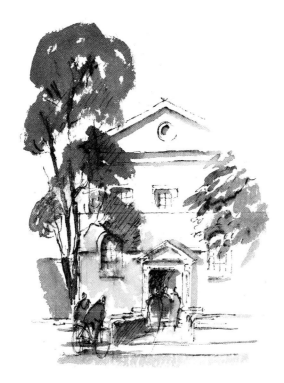

Holywell
Music Room

To the left is the chapel, to the right the Hall linked by an undercroft. The chapel contains a range of back pews kept for college servants – social rank was closely observed – and two splendid monuments, one to Sir John Portman, the other depicting two dolphins playing with a skull. The hammerbeam roof of the Hall is original, and a portrait of Christopher Wren, attracted to Wadham by its scientifically minded Warden John Williams, joins his colleague Jackson on the wall. Above the Hall staircase – evidence of a loyalty switch – is a statue of James I below the Hanoverian arms. Above the kitchen is the library. 'It will keep the books dry', said the sensible foundress.

Beyond the buildings lie the beautiful gardens. The Master's shelters a defaced statue of King Alfred; Cloister Quad a legless statue of the legendary Maurice Bowra. Two surprises remain, one old, one new, along the college's southern flank. Holywell Music Room, a demure, free-standing little eighteenth-century building like a Welsh Chapel, which claims to be the first purpose-built recital room in England. The other, some ingenious and subtly planned conversions designed in 1971 by Gillespie, Kidd & Coia. The existing houses in the street have been kept, and behind these the successful sequence of terraces, ramps and sunken courtyards containing all sorts of college activities look as if they have been there for ever. It could hardly have been done better.

Wadham seems to have enjoyed a quiet life, as befits its West Country origins, although it has to be recorded that in 1880 the whole college was sent down because of a rag.

WORCESTER COLLEGE

Entrance Door – South Range

It was once said of a Provost of Worcester College that he only took the job because it was near the railway station. (You can just see the college roof-tops from the up platform.) If true, he must have been not only a worldly and ambitious man but also a blind one, for behind its stern and straggling walls Worcester is one of the most visually seductive of colleges, secluded in its Arcadian setting of trees and turf and water and blessed with a handsome parade of buildings of many – but not too many – periods. Its neighbours – a shunting yard, a bus station and a printing works – are not glamorous, and not surprisingly Worcester turns its back on them preferring to open its three-sided quads to the famous gardens beyond.

Nearly every college in Oxford presents a guarded face to the world, but the recessed entrance to Worcester from the street is particularly severe and sunless. This makes all the more dramatic the sudden burst through into the main quad, punctuated rather than closed by a garden wall drenched in roses. To the right a formal eighteenth-century façade marches southwards to the Provost's Lodge which stands sentinel at the end. To the left a row of little Mrs Tiggy-Winkle cottages, with their roofs pulled over their ears, look as if they housed laundry maids and grooms rather than undergraduates or dons. They are in fact the oldest part of the college, largely fifteenth-century relics of the college's Benedictine origins. Each cottage was once maintained by a different abbey, and you can still decipher the arms of the founding abbeys (including Canterbury and Malmesbury) over the entrance doors. One of these doorways leads into a narrow passage revealing not, as you might expect, a row of back-gardens furnished with water-butts and washing lines, but the garden, where trees stand ankle-deep in their shadow pools like enormous and impassively hunched birds.

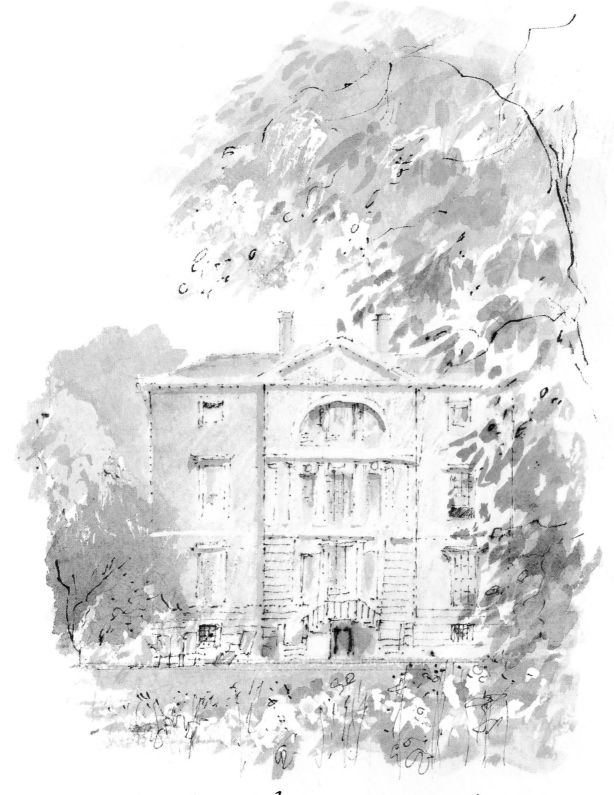

The Provost's Lodgings. Garden Front

The Lake & Gardens

Walk westwards now and then look back at the college that gazes back at you: the Provost's Lodge (architectural drawings in the college library are by Henry Keene), and the long centre block (by Dr Clarke of All Souls with Hawksmoor looking over his shoulder) that contains the library and links the Hall and the chapel. This last is Worcester's biggest surprise – apart from that dreadful day in 1873 when they discovered that a girl, Annie Rogers, had been mistakenly allowed to top the list of college entrants.

Ten years before this horrific event the Fellows, bored perhaps with James Wyatt's prim architectural understatements, had commissioned a revamp, first of the chapel and later of the Hall, by the architect William Burges. It was a brave and triumphant choice. Burges, the son of an engineer, enjoyed an unusually inventive grasp of structure linked with a passion for geometry. His personality, it is said, was engagingly boyish – Rossetti said he felt like offering him a bull's-eye when they met – and his clients, few but very rich, loved him. Although he thought Wyatt a 'vile' architect, he treated the chapel with courtesy and as the drawings in the college library show, he left Wyatt's structure undisturbed. But he smothered it with his usual gusto, transforming it with the help of his favourites, the painter Henry Holiday, and the sculptor William Nicholl, into a magnificent and blazing interior that hits us bang between the eyes. Note in particular the sensational alabaster and brass lectern (by Nicholl), Burges's own 'beastie' pew-ends and his famous inlaid inscription over the stalls, carefully orchestrated so that the single word GOD appears over the Provost's seat. (The Victorians had a gruesome relish for such practical jokes.)

After the glories of the chapel, the interior of the Hall, recently and piously restored from Burges's revampings back to Wyatt's grey–green and white patisserie, looks very anaemic and chilly. The library, serene and silent above the Hawksmoorish cloister, is ravishing: a simple country-house interior of white-painted bookcases, polished boards, and gold and black lettering, guarded over by a fine bust of de Quincey by Sir John Steell and reached by one of the college's modest architectural masterpieces, a stone spiral stair that mounts, black-railed, within a circular stone enclosure as cool and simple as the inside of a sea-shell.

Archway to the Garden

the Provosts Lodgings
from the Sainsbury Building

BIBLIOGRAPHY

A sketch-book does not warrant a bibliography but I would like to acknowledge the help I have received from the following books and authors.

Edward C. Alden, *Alden's Oxford Guide* (Alden & Co. Ltd., Oxford, first edition 1874)

John Betjeman, *An Oxford University Chest* (Oxford University Press, Oxford, first published 1938, reprinted 1979)

John Betjeman, *Summoned by Bells* (John Murray, London, 1976)

Michael Hall, *Oxford*, with photographs by Ernest Frankl (The Pevensey Press, Cambridge, 1981)

Felix Markham, *Oxford* (Weidenfeld and Nicholson, London, 1967, A. R. Mowbray & Co. Ltd., Oxford, 1975)

Mercia Mason, *Blue Guide – Oxford and Cambridge* (Ernest Benn Ltd., London, 1982, second edition)

Jan Morris, *Oxford* (London, 1965, revised edition reissued Oxford, 1987)

Jan Morris (ed.), *The Oxford Book of Oxford* (Oxford University Press, Oxford, 1978, paperback issue 1984)

Jennifer Sherwood and Nikolaus Pevsner, *Oxfordshire* (Penguin Books, Harmondsworth, 1974)

Edward Thomas, *Oxford* (Hutchinson & Co. Ltd., London, first published 1903, paperback issue 1983)

Ann Thwaite (ed.), *My Oxford* (Robson Books, London, 1977, revised edition 1986)

INDEX